D1223292

The
Crocheter's Art

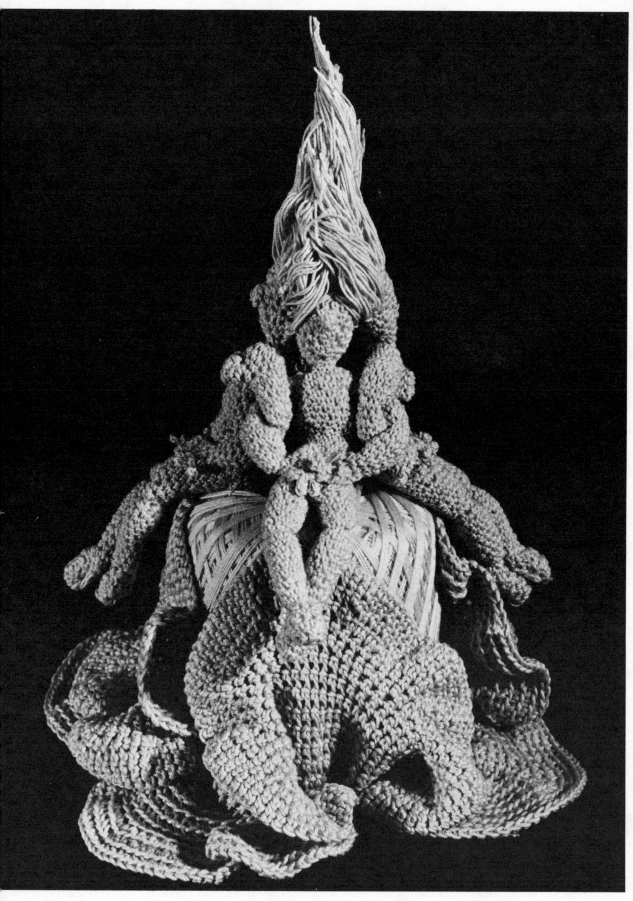

"Figures," Norma Minkowitz. Collection of Mrs. Kenneth Hall. (*Photograph by Kobler/Dyer Studios.*)

TT
820
.F453

DEL PITT FELDMAN

The
Crocheter's Art

New Dimensions
in Free-form Crochet

Doubleday & Company, Inc.
Garden City, New York 1974

Hilbert College
Learning Resources Center
5200 South Park Avenue
Hamburg, New York 14075

36,240

My special thanks and deepest appreciation to all of the following:

Marion Weissberg, who did all of the line illustrations for the book.

Malcolm Varon of New York City, who photographed all of my works shown in the book.

Elsa van Bergen, my editor, who was always patient and supportive.

And to the overseers for the entire project—my husband George; Geoffrey and Jill, my son and his wife; Lori, my older daughter; and Melissa, my youngest.

ISBN: 0-385-05134-4
Library of Congress Catalog Card Number 73–17725
Copyright © 1972, 1974 by Dell Pitt Feldman
All Rights Reserved
Printed in the United States of America
First Edition

Contents

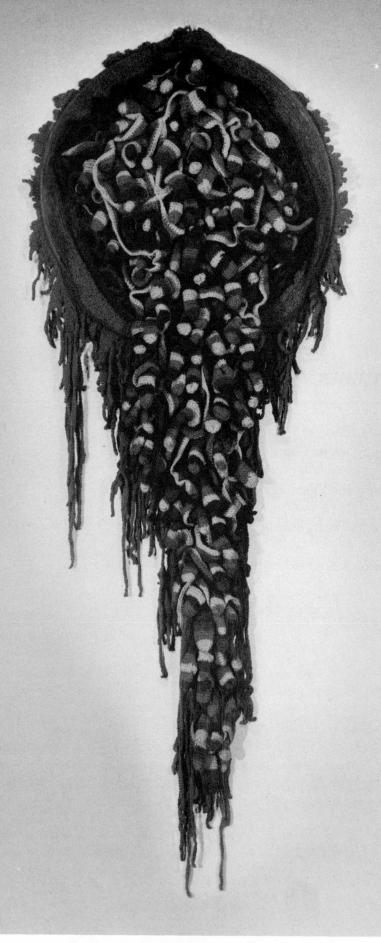

"Celibacy," Walter Nottingham. Wall hanging in wool.

1

How Crochet Can Be Art

Why is it that our modern world insists upon drawing such a very sharp line of demarcation between the arts and the crafts? In the days when the arts were really an integral part of people's daily lives, that line of demarcation did not exist . . . But today the artist lives on one side of the street and the craftsman lives on the other side and the two hardly speak to each other.

<div align="right">Hendrick Willem Van Loom (1892–1944)</div>

Now vigor, purpose and beauty infuse the crafts. No longer are they familiar exercises of technique alone. They are true art forms reflecting the creative vision of the designer-craftsman who shapes them.

<div align="right">Editorial, Craft Horizons, 1956</div>

Attempts to answer the basic question "What is art?" have left the ancient study of aesthetics unfinished, open-ended. Why, then, should we complicate things by asking, "How is crochet art?"

Simply because crochet is rapidly becoming a new medium for men and women trained in what we have known as "fine arts." This is as true of various other areas traditionally called "crafts," notably pottery and weaving, but crochet offers unique opportunities for *freedom.* You will hear one artist after another cite this as the *raison d'être* of their work. Artists speak of the excitement of exploration suddenly made wonderfully possible with the "new" materials of crochet—the working with one continuous thread and the sudden changes of direction permitted through crochet.

Many artists have been quite articulate on this subject. Listen to Janet Decker: "To be completely free in my work is my objective. . . . Crochet has succeeded in this respect as it is virtually limitless and is easily integrated with other media. Although I am employing a craft-oriented vehicle, the crochet stitch, I am not merely dealing with design and color. I am concerned with expression via sculpture . . . Crochet is not the primary medium, the medium is sculpture, but the fact is that the crochet stitch is the best to build with. There is always one stitch on the hook at a time.

This freedom leads to a learning experience for me as I work." Or hear Camillo Capua: "To come upon a thing and to comprehend it in terms of its physical matrix leaves its purpose free to stand or fall on its own strength. The simplicity of crochet allows for minimization and a more basic reaction. Perhaps the nicest thing is that the product is made of one strand of material, mathematically maneuvered, and remains one strand when complete. I believe this is vital; as vital as the strand that all things are made of."

Crochet is not really something new. It is a four-hundred-year-old lacemaking art which became home and wardrobe decoration for generations, but it has only lately matured in its imaginative uses and technical approach to the heights represented by non-functional art forms. In contrast to weaving, crochet has never been a textile craft necessary to man's survival. Lacemaking and crochet, generally associated with a particular refined way of life, are relatively modern developments, creations of the grand period of the Italian Renaissance. For years doilies and delicate lace done with microscopic needles were considered the epitome of the crocheter's art. Shown here are examples of old works from various parts of the world, with some innovative studies in crochet today. Now embellishment is not done for its own sake but to enrich a form without destroying it. More and more modern crochet demonstrates a kind of integrity or wholeness.

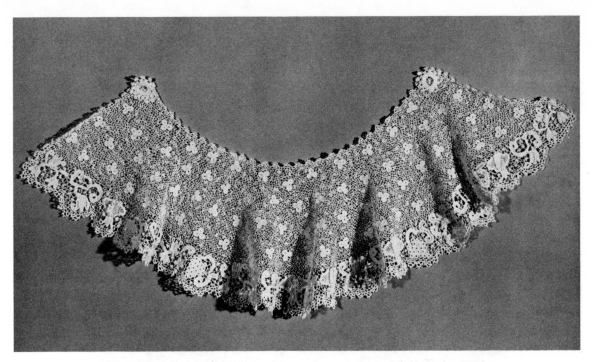

Irish crochet cape collar with shamrocks, grapes, and flowers. (*The Smithsonian Institution.*)

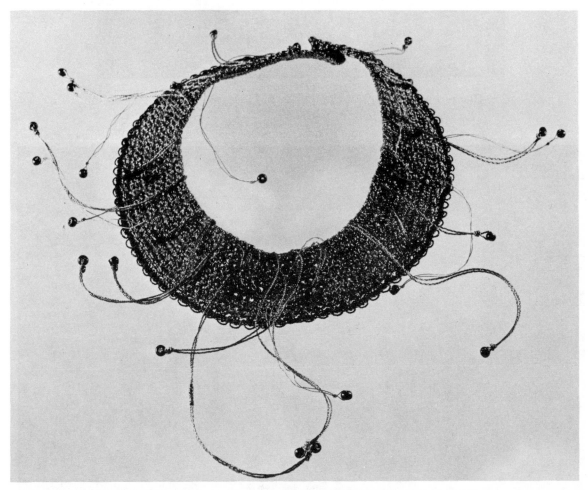

Necklace in gold lamé yarn with glass beads, Ruth Nivola. (*Photograph by Gwenn Thomas.*)

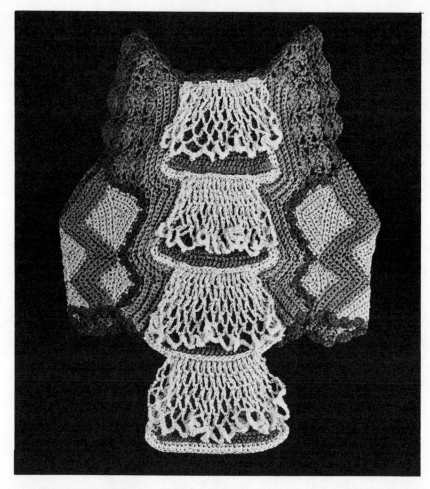

Blouse and mittens, Del Pitt Feldman. Hood/mask, Nicki Hitz Edson.
(*Photographs by Malcolm Varon.*)

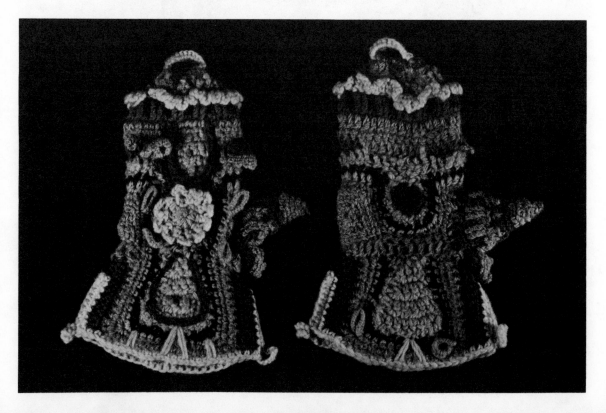

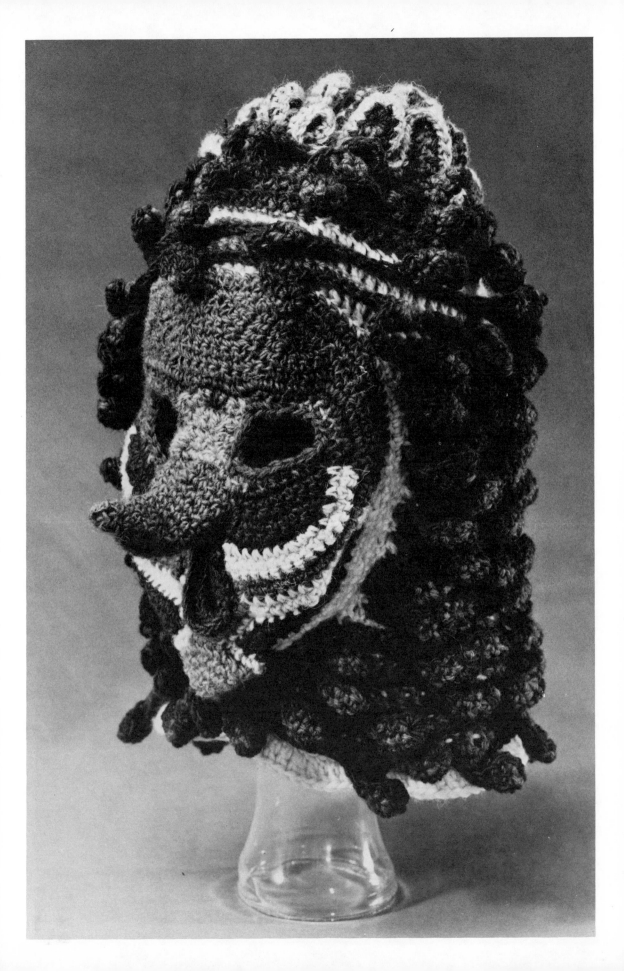

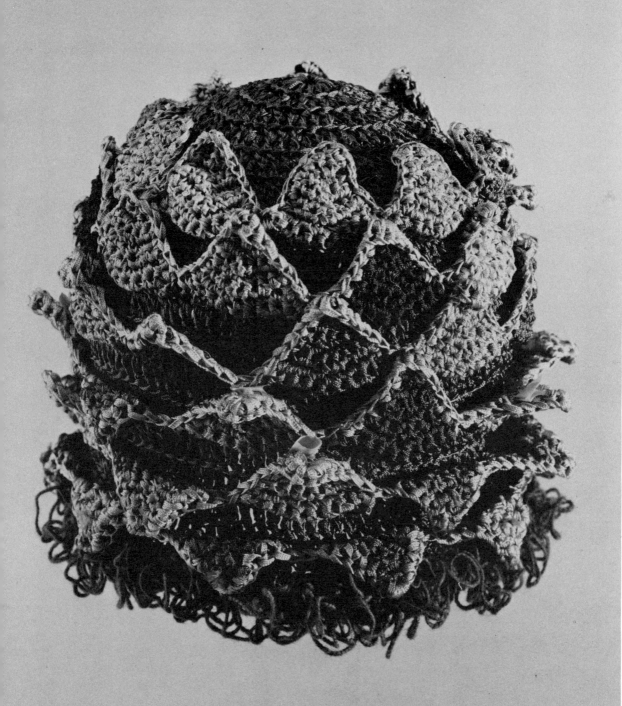

A shocking moment came when I discovered the African chief's cap (below); I was struck by the similarity with a hat (left) I had done long before. Instincts for the primitive prevail. Forms I seem to be "discovering" have already been thought of by artisans of other lands and times. Perhaps there is nothing new under the sun. We go back and forth with our art. Pre-Columbian art is completely "modern" in its simplicity of form—something we have regained after centuries generally dominated by embellishment, brought on by society's preoccupation with material values.

When analyzed, an example of modern crochet art incorporates various traces of what has gone before. What is new, however, is the tendency to blend techniques, materials, subjects into new statements. It cannot be mere coincidence that two contemporary crochet artists work independently for a number of years, come to

(The University Museum.)

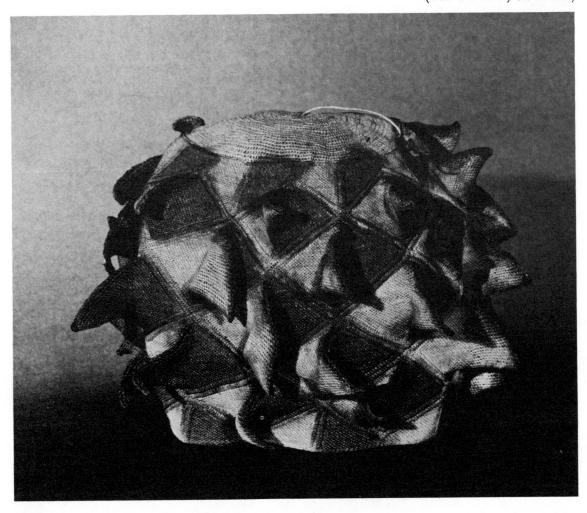

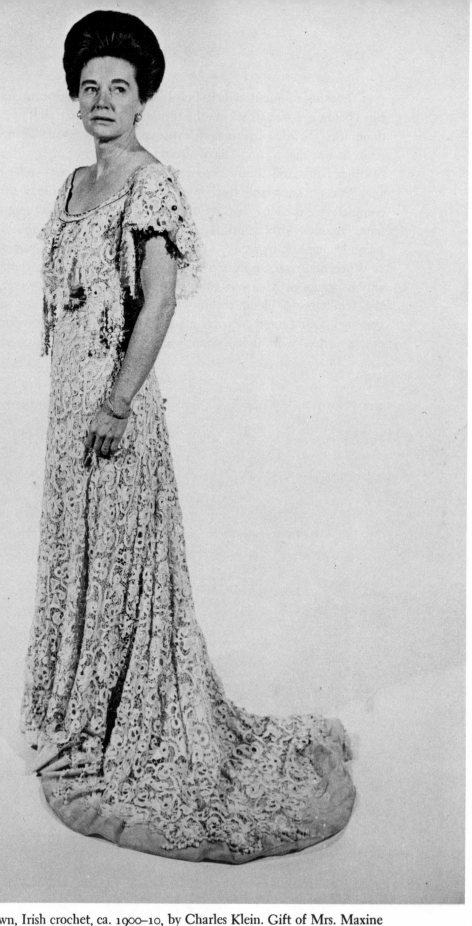

Gown, Irish crochet, ca. 1900–10, by Charles Klein. Gift of Mrs. Maxine Hermanos. (*Courtesy of The Brooklyn Museum.*)

formulate their personal artistic approaches, and then meet, compare notes and work and find they have much in common. Especially the investigation of forms and textures not previously typical of crochet. How exciting to be part of such an on-going and evolving art!

In an important way, then, crochet is in its infancy; it is a new frontier that has not been regarded as such. Its newness makes it an exceptionally appropriate avenue to creativity. Artists break rules and crash through the old barriers between art and craft. In a nutshell, the whole debate over art *versus* craft is becoming increasingly irrelevant and unimportant. Other cultures and other eras made no distinction between fine and applied or useful art. The Maori people do not label an object practical or fine art; in their minds there is only good or bad work. A common bird perch may bear carved designs as exquisite—or "fine"—as the posts of ceremonial buildings. A tribal group in Kenya has a word for beauty that can be used for aspects of many kinds of objects including milk jugs. For this group, art is a state of being, a quality. We come closest to this usage when we call something a "work of art" and mean it as an appreciative judgment.

Consciousness needs further raising in our own society, but we are slowly moving toward answering the questions cited by Lee Nordess in his introduction to the 1970 publication, *Objects: USA*, "Should nonfunctional objects alone be candidates for fine art?" "Can a chair ever be a work of art?" The art included in my book consists not only of hangings and sculpture but also of objects technically considered clothing, jewelry, and furniture. By the time you have come to the final pages I hope you will share the feeling that this *is* art. I hope, too, that terms like "decorative arts" will soon be reconsidered for as George Mills wrote, "By means of the decorative arts we make daily life an opportunity to experience qualities as we make a garden an opportunity to see flowers."

As we shall be seeing, it is not the materials—yarn, paint, or clay—used or even the category of product that makes something art but rather its expression of originality, vision, emotional communication, mastery of materials and forms. And on the other side of the street, there has always been a need for craft in the

creation of those "fine arts." As the Establishment continues to be challenged and as creative men and women seek their own best voice, each type of artistic activity experiments, borrows, questions, and innovates. In her *Ms.* magazine article, "Craft for Art's Sake," Elizabeth Weatherford wrote, "For contemporary women artists, strong personal statements have been made by bridging the categories and innovating with atypical materials and techniques . . . using soft materials and techniques such as sewing, knotting, pleating and draping, the contemporary artists . . . are turning to a new vocabulary of forms."

The techniques of crochet are accessible to anyone and are endlessly applicable. Yet when we consider the specific art contemporary crocheters have created we see a validity and quality that set objects (and their makers) apart. Beyond this book today you can view for yourself in galleries, shops, and some shows the stimulating production of artists employing crochet. Confronted with the new, ever-evolving form and aware of the irrelevancy of much of the conventional labeling, you could do much worse than rely on your own responses to crochet as an art form. The beautiful object speaks and one can "listen" and reply. The chapters that follow are designed to help you view and appreciate what various artists are up to, to discover for yourself the almost limitless scope of crochet, and experiment with your own personal combinations of acquired skill and imagination.

Ironically, it is people in the Establishment (the critics and curators)—blessedly a slowly diminishing percentage of them—who have perpetuated the conflict and confusion of art/craft. Museums regularly mount exhibits of ancient clothing and utensils; distance of time and usage allow them to be valued as artifacts, and often, art. I sense, however, that the same impulses that led craftsmen of old to achieve beauty are at work in our world today. Ages ago, art and craftsmanship went hand in hand to enrich everyday life, to please eye, mind, and soul. Frescoed walls, tapestries, and handwoven fabrics permitted our primitive forebears to surround themselves with their own creativity. Many tribes were forced to wander across continents. They gave up their homes but took along their most valuable possessions, the very utensils they made and used to sustain life as well as to adorn it. This identical philosophy was

12

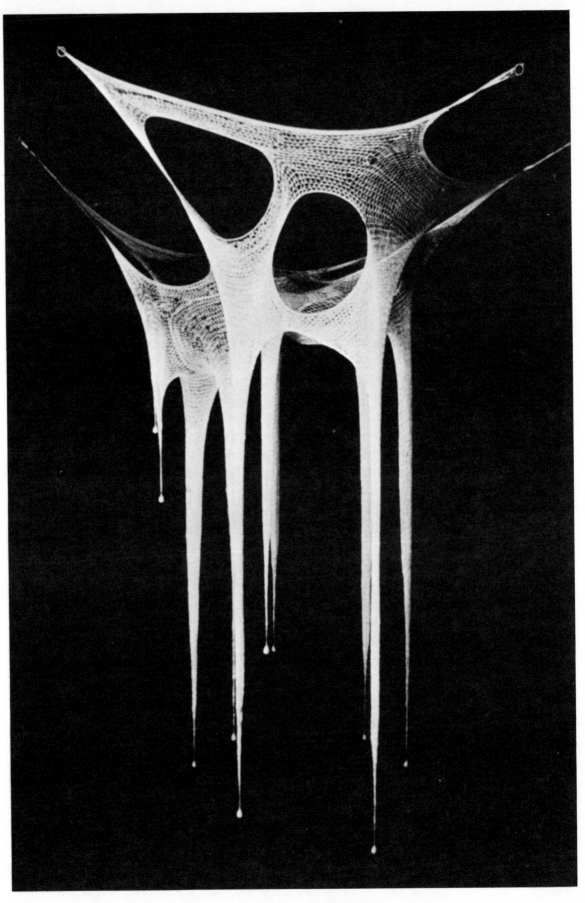

"Hanging 101," Toshiko Horiaki. (*Photograph by Lester Andersen*.)

behind the fall 1973 show, "Portable World," at the Museum of Contemporary Crafts in New York City. People don't need or want to be surrounded with a lot of mass-manufactured items. The young especially have a greater need to make the few things they have beautiful so that the joy of using them remains strong.

Good craftsmanship is increasingly valued by so many that collecting outstanding works of inspired artist-craftsmen has become both adventure and status. This is so true that a talented creator of crochet jewelry, Ruth Nivola, remarks, "People cannot afford good craft unless they buy it as a painting or a jewel. Today the machine turns out cheap objects, but craft is a luxury. It is a terribly important luxury, almost a necessity, for it is now a luxury of the. spirit."

The point is worth repeating: We still have a long way to go. Crochet as art is now a fruitful and exciting subject because it is a most dramatic example of the need to look at craft in a new way. At a fiber art show, a finely woven hanging is all too often spoken of as a "shag rug on a wall." In the United States, particularly, we lack enlightened standards–too rigid a term, anyway—or criteria for evaluating fine craft. The importance of *Craft Horizons*, the publication of the dedicated and energetic American Craftsmen's Council, cannot be slighted. Their intelligent coverage of shows all over the country *has* done much to help. A typical review begins, "Ron Hickman, executive curator of the [Fine Arts] Gallery, installed the Allied Craftsmen of San Diego's twenty-fourth exhibition with creative aplomb . . ." I was glad to read further and note their citing of innovative crochet (especially a chair by Carol Shaw) as part of that show.

There has been more and more inspiration and direction coming out of schools and museums (although to date I personally find elitists among the crafts enthusiasts tend to overdo insistence on the importance of university training). Now, at the Museum of Contemporary Crafts there has been a tremendous increase in activity. People are using the growing facilities to help them set up shows, write books, go into business, and find out where they can learn various crafts. Currently, membership in the Crafts Council has reached over 34,000.

Paul Smith, the museum's director, has always tried to set up

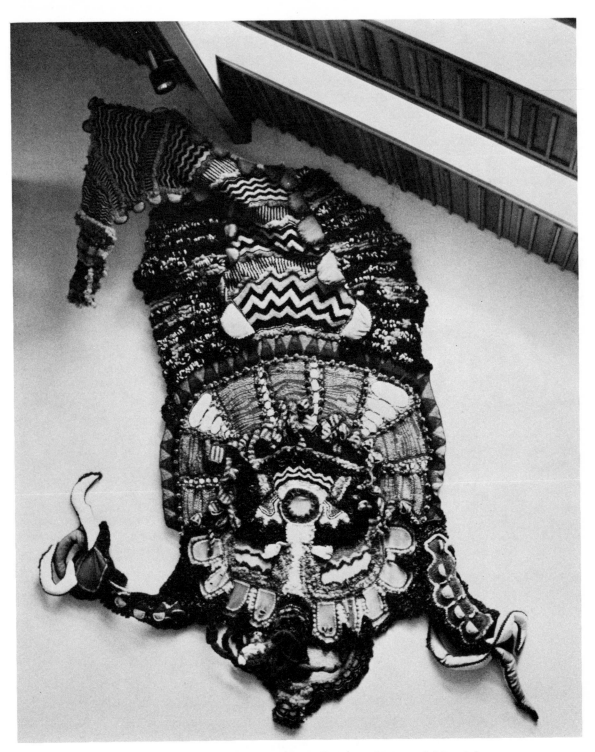

"Lucretius and Rusta," Janet Decker. Collection of Mr. and Mrs. John Bennett, Toronto.

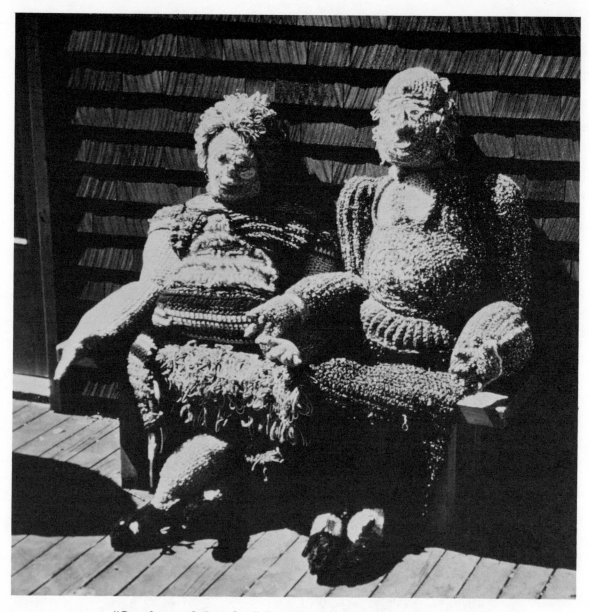

"Grandma and Grandpa," Bonnie Meltzer. Life-size figures which can be sat on.

exhibits to foster growth and awareness in diverse areas. The fall 1972 show on kitchen utensils, which had great public response, helped many people to choose a basic tool for cooking while considering elements of design as well as functional possibilities. The show brought the old and the new together. At the same time, it encouraged aesthetic evaluation in each of us. Public participation has played a key role in setting up other shows with equally satisfying results. Their mask show in 1971 was a delight to children and adults alike. A make-up artist was present to do up anyone's face to his or her liking, and the results were spectacular. The public could view masks from all over the world which employed techniques including macramé, crochet, paint, fiber, and found objects—all were used in wonderful ways.

Mr. Smith believes that good craftsmanship cannot be separated from a work of art and that time will decide how valid the work is. An interesting point raised in his conversation with me was that the "American Style" is not a *definite* style. Therefore, it is more innovative than is usually the case in Europe, with their longer history of technical skill and consciousness of tradition and system of apprenticeship. Here, we often see a particular craftsman who branches out in his or her own direction and brings a new concept and approach to a medium. This sets off a chain reaction in others working in the field, each adding and building in his own way. A bench mark was the museum's "Sculpture in Fiber" show, in the winter of 1972, which showed the work over the past decade of twelve artists living in America. Each developed fiber construction in a unique three-dimensional way, employing knotting, macramé, braiding, plaiting, knitting, twining, basketry—and crochet.

Speaking with a pioneer like Mildred Constantine is also a delightful and encouraging experience. Not only is she a vital part of the art world as a teacher and author, but she is very involved with the lives of the artists as well. She always gives a helping hand and lends a sympathetic ear. Mrs. Constantine has a rare perception of what is happening around the world and has been a forerunner of many exciting innovations in the areas of art and craftsmanship. In 1966 she conceived the idea of having a wall-hanging show at New York's Museum of Modern Art. The next year, Jack Lenor Larsen, the noted fabric designer, helped develop the project, but

it wasn't until 1969 that the show was finally launched. A great and inspiring show it was, too. But the critics hardly noticed it; the show was not reviewed in any of the major newspapers. The only review appeared in *Craft Horizons*. It was the public response that was notable. And the inspiration and the results of that show have been reverberating throughout the country since.

As Mrs. Eudorah Moore, curator of design at the Pasadena Art Museum, has said, "People who call themselves craftsmen are venturing into the area of fine arts, doing things purely for aesthetic purposes. The thing that is intriguing to me is that this material speaks with such a quiet voice . . . but the cultural statements are as profound as the more self-conscious statements that are designed to be cultural statements."

So, innovation in creativity abounds, and the nature of our response—critical and emotional—is in a state of change. It is a good time to look more closely at what makes craft art; specifically, how crochet is this minute evolving as an art form. That this craft *is* art can no longer be in doubt. In its own ways crochet meets those definitions or criteria great thinkers have been formulating through the centuries. De Witt H. Parker: "Imagination and physical embodiment are two aspects of a single fact." Jacques Maritain: "In the humblest work of the craftsman, if art is there, there is a concern for beauty, through a kind of indirect repercussion that the requirements of the creativity of the spirit exercise upon the production of an object to serve human needs." And especially pertinent to our discussion is a comment by Morris Weitz: "Art itself is an open concept. New conditions (cases) have constantly arisen and will undoubtedly constantly arise; new art forms, new movements will emerge . . . Aestheticians may lay down similar conditions but never necessary and sufficient ones for the correct application of the concept. With 'art' its conditions of application can never be exhaustively enumerated . . ." Art is the medium for the most highly individualized contribution man can make. Like art—as art— crochet is the product of imagination, something that all of us possess to a degree. While few can be geniuses or leading artists, each of us can not only respond, but create.

Again, I find most helpful the philosophy of cultures supposedly more primitive than our own. Eskimos, for example, are far more

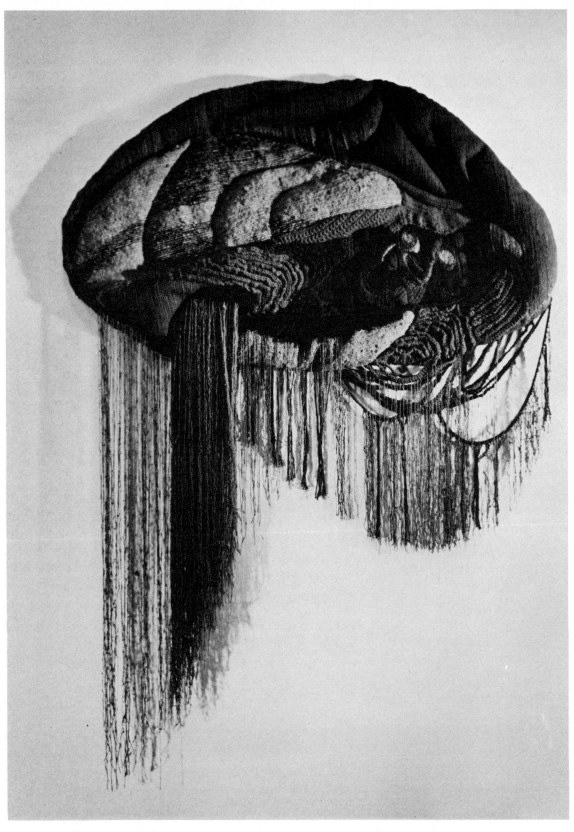

"On and Around," Norma Minkowitz. Crochet, stitchery, trapunto, hooking. (*Photograph by Kobler/Dyer Studios.*)

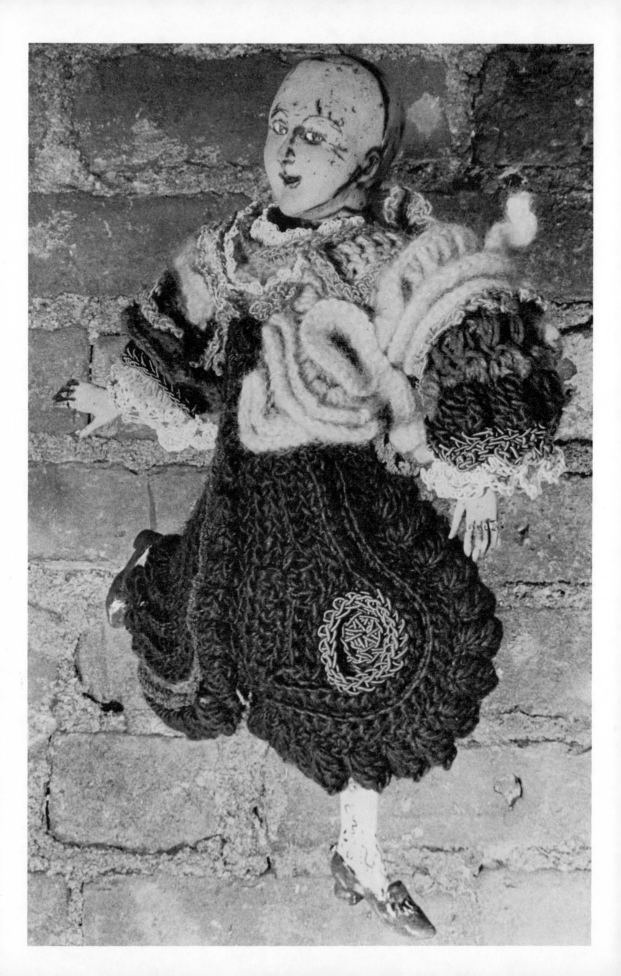

interested in the artistic act than the output as such. They feel a carving, like a song, is not a thing; it is an action. When you feel a song within you, you sing it. Belief in this, along with respect for the accomplishments of individuals such as those included here, motivated my writing this second book. It is not an idle belief, either. Time and time again, I have seen through working with students—beginners as well as artists advanced in some other medium—how more of us than we think can put our own signature on an evolving object and thereby create artistically. One young woman who personifies this is Barbara Sexton. Within her career in illustration she felt herself drawn to fantasy of figure, and she developed this as she turned to ceramics. Then she began to crochet, which opened up the area of color for her; working with fiber gives you a waiting palette. With encouragement she combined the several areas of her artistic knowledge and the exquisite doll shown here is a wonderful example of fine ceramic work combined with crochet. She found an original means of expression, unconventional, individual, built with the blocks of her experience and sensitivity. An object or product and the means or activity of creation became intertwined.

The word art derives from *Ars*, coming from an Aryan root signifying join or put together. Crochet as art joins much more than stitches and yarn. Crochet lends itself in a unique way to the joining of accumulated techniques, viewpoints, and experience. The range of possibilities within crochet for artistic self-expression are only beginning to be recognized. I hope this book can aid in furthering that recognition.

Facing page:
Doll by Barbara Sexton, using wool, mohair, cordé, and metallic yarns.

2

Forms and Fiber

Art and life ought to be hurriedly remarried and brought to live together.

Hugh Walpole (1884–1941)

746.434
F 312
36,240

Crochet is the manipulation of fiber with a hook. This remains true whether the end result is a simple garment or a highly imaginative art form, or something in between. Whatever the end or achievement, certain stitches are the means to that end. As we have seen, however, in creating art in crochet, there is great freedom.

Emphasis of texture/embellishment and simplicity of form are the two basic elements used to achieve different effects. Sometimes it is not a question of either/or, yet in the work of artists included in this book various kinds of emphasis reveal themselves. To become more responsive viewers of their finished, individualistic art, let us now delve into the basic techniques of construction they share. Such know-how will allow you to analyze and appreciate what you see more and more frequently in galleries today. Still more exciting, though, is the opportunity such tools and techniques give you for your own self-expression. To start you on such exploration, this chapter concludes with two experiments in achieving form.

FIBER

Shopping for yarn can be the beginning of a piece for me and tends to nudge me in one direction or another. Bits of color might lead

Hilbert College
Learning Resources Center
5200 South Park Avenue
Hamburg, New York 14075

me to weave them into a crocheted tapestry, to create a painting with the added dimension of a raised surface. I might elaborate by repeating areas of color and design.

This I call *embellishment*. In my final chapter I will demonstrate ways I use and combine stitches for specific results. On the other hand, when the fiber is especially beautiful in texture, I try to keep my piece as *simple in form* as possible, so that the beauty of that fiber will come through.

You will see in the photographs in the next chapter the ways in which simplicity of form leads us to focus on the materials used as well as the elemental stitchery—and vice versa. In the jewelry crocheted by Ruth Nivola, form, technique, and metallic yarn are wed with unusual ease. As Jean Block once said of her work, "imagine this gossamer webbing worked with flashing finger-tips into chains, tassels, bracelets, and chokers rich with muted luster and matchless elegance." Judy Kleinberg's crocheted chain links were made with brass and copper wire, very unusual and effective materials. She explains that these "three continuous tubular links emerged from a conceptual interest in permanent entanglements of elements in a construction. Each link is free-moving and quite flexible. The tactile quality is quite odd, somewhat springy. I found myself newly concerned with image in this piece. Image in a very linear sense, which comes to life as the piece is moved in the light. Image in a sense that there is no real line defining the outer limits of the structure, but rather it is implied by the many intertangled loops of crocheted wire." Judy truly explores with and through her materials. You don't need to begin with a particular "conceptual interest" though. Her cylindrical basket construction developed without any plan. Its scale (31 inches high) and its fiber, a very lustrous jute roving which crochets into a dense knobby relief texture, are dominant.

Anything you can wrap or wind around your hook is worth experimenting with. In this renaissance of crochet, the sky's the limit. Your own personality has a lot to do with what you choose in the way of fibers and colors, thereby making whatever you do unique. A sense of the past and the heritage of needlework has become part of my work, in terms of sources of inspiration for design and as it adds to enjoyment of the materials of crochet.

26

Close-up, cylindrical basket construction, Judith I. Kleinberg. (*Royal A. Lyons Photography.*)

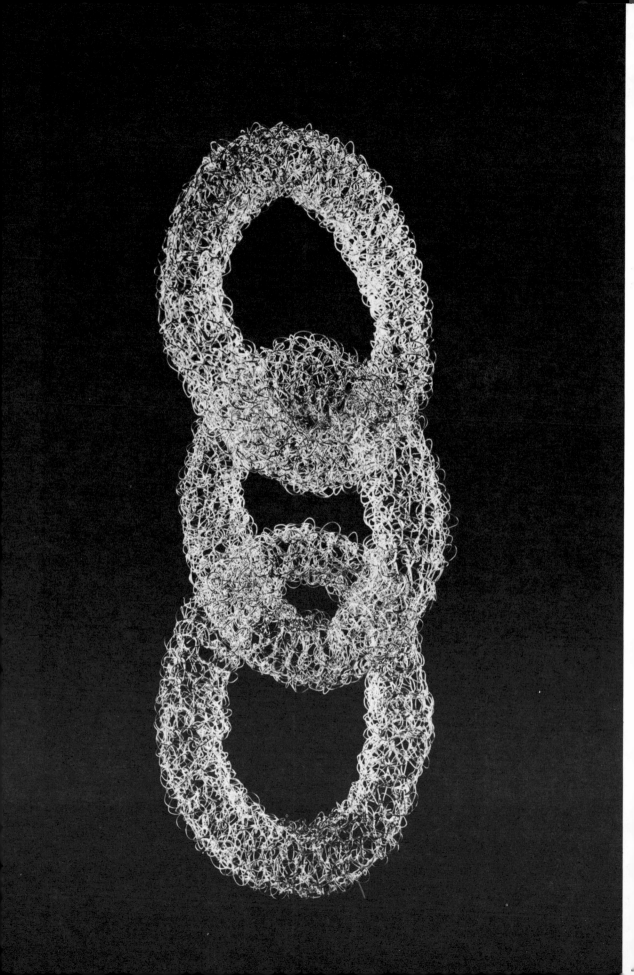

Crocheted chain links, Judith I. Kleinberg. (*Royal A. Lyons Photography.*)

From its origins in the sixteenth century to the first half of the present one, cotton was primarily used for crochet. Known as "karpas" and "koton," cotton was mentioned at least as early as the time of King Solomon as being imported mainly from Egypt. In India the first reference to cotton or karpassi is in the ancient Hindu laws, or Code of Manu (ca. 400 B.C.–A.D. 200). Archeological findings at Mohejo-Daro indicate that cotton was known and used in that country as early as 3000 B.C. The cotton plant was called by the ancient Chinese the "lamb plant"; it was said the cotton lambs grew shrubs, each cradled in its own downy pad, the bolls bending down and grazing on the adjacent herbiage. When all the grass had been eaten the lambs disappeared, leaving their coats behind. Early Greeks referred to cotton as the fiber of wool-bearing trees. In 425 Herodotus wrote, "The wild trees in India bear for their fruit a fleece surpassing that of sheep in beauty and quality and the natives clothe themselves in cloth therefrom." Our own mothers and grandmothers produced lovely tablecloths and bedspreads which we appreciate anew. Shown here is a late nineteenth-century American piece; part of a lambrequin, a short drapery decorating the top of a window or door. Still available in shops, such crochet cotton produces a finer, softer stitch but is not as widely

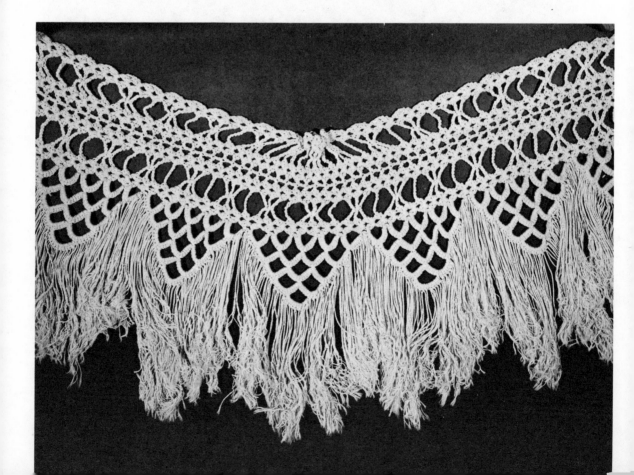

found in crochet art as is wool, with its body, range of roughness, and attractive homespun quality, or rayon, for durability.

Wool was the principal fiber used for textiles in the pre-Christian era in Palestine, Syria, Babylon, Greece, and Italy. The Babylonians and Assyrians, as well as the Phoenicians, developed a marvelous knowledge of the textile arts at the same time as the Hebrews and Egyptians. Wool was their most important fiber. The wealth of nomadic peoples was measured by the size of their flocks of sheep and goats. In all aspects of crochet today, wool is being fully utilized. The hood by Janet Decker, shown on page 34, incorporates leather and other hard materials but almost celebrates wool, here as raw fleece, some hand-spun and hand-dyed.

Today we have exciting synthetics, those man-made substances in which elements are combined to make new compounds. A chemist can put two or more simple chemical compounds together to make a more complex product with new properties. First discoveries in this rapidly developing field were made with nylon. Its development began when research workers tried to reconstruct the protein products in the human body. By combining basic elements of body proteins, they obtained nylon fiber. Synthetics are replacing some natural fibers because they are stronger, last longer, and cost less. They go by various names—Acrilan, Dacron, Dynel, fiberglass, Orlon, rayon, vinyl as well as nylon and others—and are a boon to crocheters for the textural interest they add. I find rayon and nylon fibers good for wall hangings where strength and durability count. The fiber you use also tells the story of our time. As Marshall McLuhan says, "The medium is the message."

It is desirable sometimes to go out of your way to find material that is unusual. Consider as "yarn" leather, raffia, or metallic fiber.

Remember it takes the same amount of time to work with fine material. Why waste a beautiful design and hours of work on cheap worsted? Lots of times, I find materials that give me just the right impetus to start a brand-new project, and I'm sure you, too,

Facing page:
Lambrequin. Cotton. American, late nineteenth century. (*Courtesy of The Brooklyn Museum.*)

31

Cordé.

Suede stripping.

Raffia.

Synthetics.

Chenille.

Rayon ribbon.

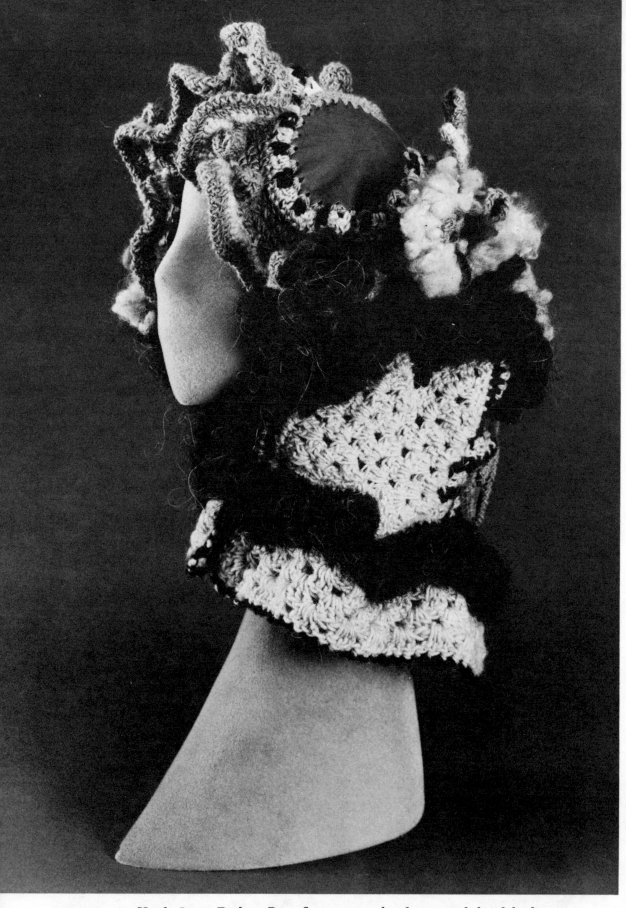

Hood, Janet Decker. Raw fleece, some hand-spun and hand-dyed, leather, trimmed with button made of slice of bark. (*Photograph by Malcolm Varon.*)

have had these very same feelings. My walking tours always surprise me with great finds. Try to keep track of where you pick up odd materials and hold on to samples so you know what you have and where to find them again. It's so easy to go on binges with one type of yarn and forget that you might have collected a variety of others that would work nicely together. Many yarn shops have close-outs from time to time, and if you find an interesting bargain, make sure you buy enough then to finish your project.

Don't think, however, that you're going to find materials only in yarn shops. Some of the most interesting surprises can be found in marine supply stores, cordage companies, stationery suppliers, trimming and notion stores, millinery suppliers, leather manufacturers. Explore the industrial areas of your city; there are surprises hidden in those cavernous warehouses. It's fun to try to explain to the businessmen that you want to crochet with materials that they've been selling as packing twine for a hundred years.

Another great source of materials is catalogues from yarn distributors. There are many good ones in the United States and abroad, and the prices are usually much lower than in retail stores. Of course, there are minimum orders on some and bigger discounts on larger orders. Check the craft magazines and trade information with fellow craftsmen. There are sometimes booths at craft fairs or special days at craft schools set up for exchange of unusual materials. Just looking through samplers can be inspiring. To make a truly beautiful article, you must love the material you're working with.

If you can't find yarn suited to your particular artistic sensitivity, why not try some hand spinning? Once you've become proficient at crocheting, spinning your own wool makes sense because with the spinning process in the craftsman's hands, greater control can be exerted on the finished piece.

Sharon Hedges who teaches spinning at The School of Crochet Art supplied the following information.

The fleece can be chosen according to the use (wearability, softness, length of fiber, etc.) as different fleeces are suitable for different purposes. You can control the thickness, texture, and tightness when you hand spin. The wool can then be dyed (or dyed prior in the fleece) with vegetable dyes for softness or chemical dyes for

brightness, and can then be plied (if desired) in a variety of ways.

Even if you have no specific use in mind for the wool you are spinning, hand-spun is a beautiful compliment to machine-spun wool; it softens harsh tones with just one or two rows here and there.

To me, there is no nicer feeling wool than hand-spun—it has been treated gently from start to finish and is a product of time and skill rather than unfeeling machine hands. It has natural luster that hasn't been pulled or twisted out of it.

A very good concise book on spinning is Elsie Davenport's *Your Hand Spinning*, and even more complete is Allen Fannin's *Hand Spinning*.

If you spin your own yarn, the natural next step would be to dye it yourself. I find it very difficult to get yarns in subtle colors. The color you see on ancient tapestries and frescoes are easier to duplicate with the vegetable dyes that were used in ancient times, and the way natural dyed colors mellow with time adds to the organic feel of some pieces.

It is a very exciting process to see fiber without any color suddenly spring to life in the vat. Even if the color is uneven in spots when it dries, it can be another fascinating dimension in your work. Dyeing indigo blue, for example, is a unique experience. It looks all yellow in the vat, but as soon as it hits the air it miraculously turns to blue. It's fun to be able to pick leaves or flowers and make your own elixirs. The Brooklyn Botanic Garden has a good pamphlet on dyeing, "An Introduction to Natural Dyeing" by Robert and Christine Thresh, and a number of books for the beginner have recently been published.

THE VOCABULARY OF CROCHET

To learn to be free, it is still necessary to understand the basic concepts and have some discipline in creating basic forms and achieving uniformity of tension. Very important, too, is the ability, when needed, to follow old pattern stitches as part of your design. With every art form the study of age-old principles and the technical mastery of them is important in order to give the freedom

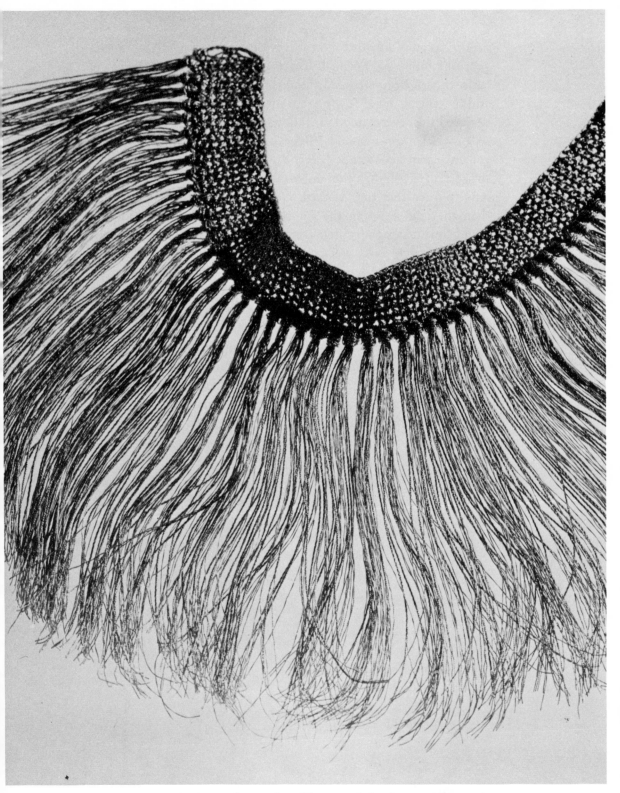

Lamé in jewelry by Ruth Nivola. (*Photograph by Gwenn Thomas.*)

needed to go in any direction you wish with an underlying intelligence of form. So, my first advice is to acquire a knowledge of basic stitches, beginning and ending rows, increasing and decreasing, and in general, building up your stitch vocabulary. Once you understand this, everything that follows will fall right into place.

It is always amazing how stitches that look so complicated when you first start to crochet become really simple after that initial struggle of mastering the single crochet. Many of my students have told me that they worked harder with the first Chain Stitch than they did learning the Popcorn Stitch. It's a good idea to spend time making up stitch samplers so you will remember how a particular stitch looks when you want to use it sometime in the future. This project, in itself, can also be a creative endeavor.

In my previous book, *Crochet: Discovery and Design,* I gave instructions for some favorite stitches. In the following pages we will use the simplest stitches to construct basic forms.

Note that the diagrams which accompany instructions for creating forms use a "shorthand" system to abbreviate basic techniques. The most basic terms used in crochet are as follows. Before going on, become familiar with the symbols given below for they will be used for projects described later in the book.

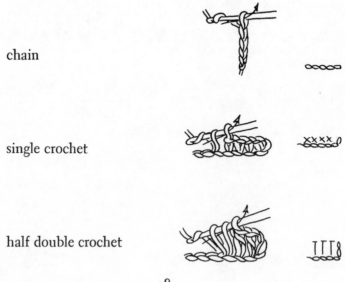

chain

single crochet

half double crochet

38

double crochet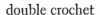

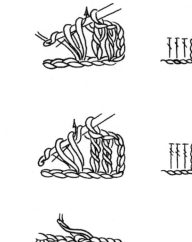

treble or triple crochet

slip stitch

* repeat from previous asterisk

Choosing the right needle with the right yarn is another area that requires a little study and experience. I like having at my disposal a full range of every size hook—including any new sizes that become available. There are steel hooks ranging from 0 (the largest) to about 13 (the smallest) and aluminum hooks A to K. The sizing systems differ from manufacturer to manufacturer. I do not recommend plastic; the hooks bend and break easily and are squared off, making work more difficult. You can even carve your own if you wish. This was customary in years gone by and I sense more and more people returning to basics in this part of the craft too. After deciding what you are going to make and what stitch or stitches you are going to use, work up a little swatch about 4 inches square to see if your stitch gauge and material make a happy blending. If you want a lacy effect, try a larger hook; if you need tight shaping, use a smaller one.

1. How to pick up stitches from the foundation chain:
 a. through top loop (most often done)
 b. picking up whole chain, leaving bottom loop
 c. through bottom loop (leaves full chain on reverse side)

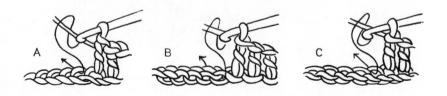

2. Understand the math of stitches to begin and end a row properly:

 in single crochet: end with chain 2, turn.

 half double crochet: end with chain 2, turn.

 double crochet: end with chain 3, turn.

 treble crochet: end with chain 4, turn.

3. Always turn your work in the same direction—counterclockwise—at the end of each row, to keep work consistent. Make sure your chains when you turn are going straight up. You can check this by looking at the side of the work away from you. Since these chains are the first stitch on the next row, your next stitch would go into the second stitch in the row. When ending a row be sure you go into the top stitch of your turning chain, because that is your last stitch on the row.

4. Make sure to keep sides even. Count how many stitches you start with on the first row and at the end of every row for a while until you are sure you understand where to begin and end a row properly.

5. There are three ways to go into any stitch and three different effects:
 a. through both loops.
 b. through front loop.
 c. through back loop.

 These create *variations* on a stitch.

40

6. Increasing or decreasing:
 To increase, either
 a. insert hook twice in the same stitch, or

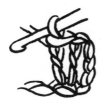 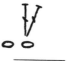

 b. add a chain stitch.

 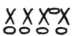

 To decrease, either
 a. skip a stitch, or

 b. pick up two stitches at once (the front of first stitch and
 back of second stitch at once) to avoid a hole.
 c. slip stitch to the next stitch you wish to start with.

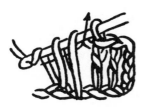 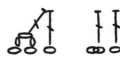

7. Changing colors:

If you are changing colors on the same row, start your stitch as usual and at the last step of the last stitch (2 loops on hook), pick up the second color and pull it through loops on the hook, completing the stitch. Drop first color, leaving the thread hanging until it is picked up in the next row. You can also carry first color along *loosely* if you are going to use it again in the same row. This keeps the back of your work neat and your tension even.

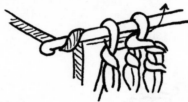

FORMS AND BUILDING

Building and a knowledge of form are essential. I'll start with basic and classic forms and then go into more amorphous forms and three-dimensional construction.

The start of a round form can lead you in many directions. Many things you will want to make require round forms that are flat. By the way, if you are following this method and your work is not flat, use another needle: If your work is cupping, use a larger size hook, and if your work is ruffling, use a smaller hook. Continue this method until the piece is the size you want.

Rounds (worked in double crochet)

Starting with a chain of 6 stitches, join with a slip stitch, chain 3, and do 11 double crochet in the center of the ring formed by the chain. Join with a slip stitch to top chain of first 3 chains and slip stitch into next space. (Note: 2 slip stitches were made, because you are now working in between the bars of the stitches.)

Row 2: Chain 3 and double crochet in same space, do 2 double crochet in each space (increase made) for the rest of the row and join with a slip stitch. Slip stitch in next space. There are 24 stitches now.

Row 3: Chain 3 and double crochet in same space, do 1 double crochet in next space and do 2 double crochet in next space (notice

you always increase in every space where an increase has been made on previous row) with 1 double crochet in between until the end of the row. Slip stitch to join and slip stitch in next space. 36 stitches.

Row 4: Chain 3 and double crochet in same space, then do 1 double crochet in next 2 spaces, continuing to end, always increasing in top of an increase stitch. 48 stitches.

Continue in this manner until desired size is reached, noticing that you always increase 12 stitches on each successive row.

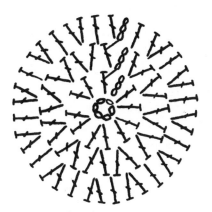 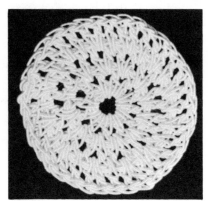

Square (with border)

Cast on as many chains as the width of the square you desire, then just work even in double crochet or any other desired stitch until the length is the same size as the width. Border square with single crochet to finish, doing 3 single crochet in the same space in each corner.

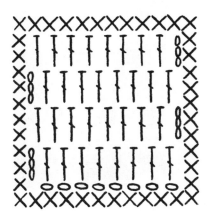 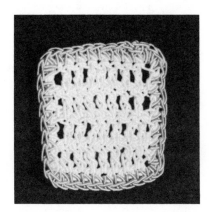

43

Triangles (worked in double crochet)

This can be started at the point or base of the triangle. Starting at the point, chain 4, double crochet in last chain (2 stitches made), chain 3, turn.

Row 2: Double crochet in same space and do 2 double crochet in last stitch. 4 stitches made.

Row 3: Work even without increase.

Continue working in this manner, always increasing at the beginning and end of every other row until desired size.

Notice that I have given you all these instructions in double crochet. However, you can translate this same principle using a single crochet or treble, whichever you feel is most suitable for your design. You can also increase every row instead of every other row.

To turn a triangle into a diamond, continue at the top of the triangle, using the same progression of stitches but reversing the increase to a decrease to reach the tip, leaving 2 double crochet on the row.

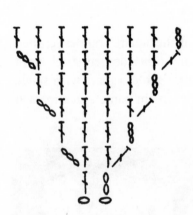

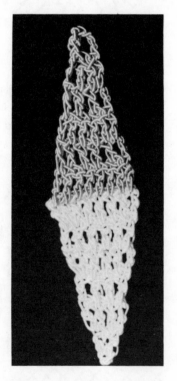

44

Ovals

When working an oval that is very large, a system of measuring has to be devised in order for your piece to keep a nice shape. Your oval will become rounder the more rows you add, so if you want a more elongated shape, use fewer rows and start with a longer chain.

Start with a chain the length of the inside of your desired size of oval. Make 3 extra chains for your first double crochet and do 2 double crochet into same space, into fourth chain from hook. Double crochet in every stitch across row until last stitch. Do 5 double crochet in last stitch to turn and continue around picking up the other side of your chain stitch, doing a double crochet in every stitch. In last stitch, do 2 more double crochet in same space and join. Slip stitch into next space and, like the round, increase on top of every increase from row below. You can now continue in this manner as shown in diagram until the oval is the size you want.

Now with these basic shapes, you can really start constructing. In the photo, I have broken down the shapes used in a belt to show you how to combine forms.

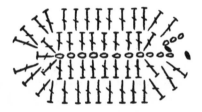

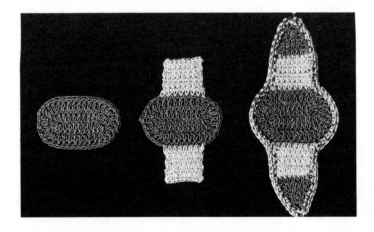

Because you'll probably be working from the forms you have already made, or joining them together, it is always a good idea to go around each form with a single crochet to give you a good foundation to work off of. This can be done in the same color or a contrasting one, depending upon the effect desired. There is no set way to do this. Of course, circles and ovals already have finished chain stitch edges, but triangles need to have a finished edge along the sides of the double crochet stitches.

A basic guide in bordering forms is:
1. 1 single crochet in each stitch of single crochet; 3 single crochet at the corners to square things off if you want a sharp corner and to keep your work from curling.
2. 1 single crochet in top and bottom of bar made by double crochet. Single crochet in between top and bottom of bar.

If work starts to ripple, make stitches farther apart. If it buckles, add stitches. Feel your way along edge until you find a comfortable way to keep your work neat and flat.

Amorphous Forms

Now that we've covered pretty basic things that have a more or less prescribed way of performing, let's delve into amorphous forms.

In the diagram I have shown you a shape that I often choose for my students. They always have fun with this one.

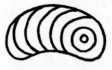

First thing to do is to cut out a piece of cardboard or stiff paper into this shape, then get a hook and some yarn and see if you can follow the form using some of the various approaches as shown in the three illustrations. Maybe you can figure out something of your own. Here is a very good place to start freeing yourself and to use

46

some ingenuity. If you want to incorporate this shape into outside form (or any other shape) do a single crochet stitch around the form to give you an even border.

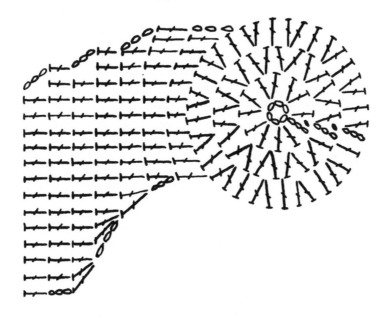

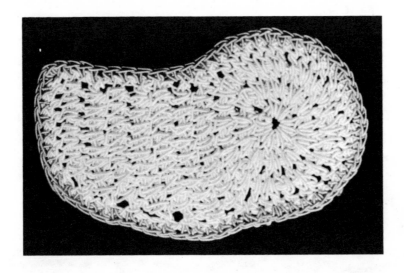

Filling Spaces Around Form

There will be many times you will start with a shape and wonder where to go from there, and you can approach this problem in two ways.

1. By building out form on form as previously shown. Or,

2. You can fill the space between triangular points, which forms a triangular shape in this manner. Pick up stitches along one side of the right angle bar shown below and skip over center (or corner) stitch or stitches. Pick up same number of stitches on the other side of bar. On the next row, decrease 1 stitch at each end and 1 stitch in the center (or 2 stitches in center if necessary to keep even amount of stitches) until there are 2 stitches left. Join and break off yarn.

Try these other shapes:

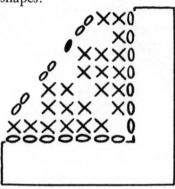

The Wiggle

Row 1: Start with 36 chains.
Row 2: Do 5 single crochet stitches, increase in sixth stitch, work 5 more stitches in single crochet and decrease in twelfth stitch. Continue in this way leaving last 6 stitches in single crochet.
Row 3: Continue working in single crochet and increase on top of every increase stitch. Decrease on top of every decrease stitch.

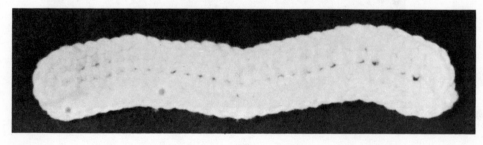

Triangle on Top of Square

Start with a square form and work around a corner of the square, increasing 3 times in the same space at the point of the square.

WORKING WITH HARD AND SEMI-HARD OBJECTS

Objects such as beads, mirrors, shells, clay, metal, feathers, leather, fur, etc. are things we don't necessarily look for—they usually find their way to us. Maybe it is a precious piece of broken jewelry or something we found in the woods or on the beach that is very special. I don't know how you feel, but I tend to collect things, waiting until the right moment for their special use in embellishment.

Incorporation of objects have throughout history served artist craftsmen. To this day, certain Asiatic groups decorate lime containers with shells, beads, fur, or grasses, and the attention lavished on the work give utilitarian things splendor and distinction.

Beads

The search for the proper bead with the proper yarn will probably take up more time than mastering the technique, which is quite simple. I always try to find beads that are particularly interesting from someone's discarded old jewelry. Maybe you have discovered a number of places that sell unusual beads from Venice or India or

even from Africa or other countries where beads are an integral part of the craftwork done there. They are usually made of glass, clay, wood, shells, or even seeds. Plastic beads can sometimes be interesting to use but be careful about how they clean. Many things disintegrate in cleaning or washing, so it is a good idea to ask the salesman or your local cleaner.

The size of the hole in the bead will have to determine the thickness of yarn you will use. Or vice versa. Make sure your beads can be strung easily onto the yarn and that they are not too heavy for the area you want to use them on. They might tend to pull your work out of shape. It is wise to use a smaller, closer stitch to give the beads the body they need to stay neatly in place. I find it a lot easier to string beads that are already strung by just waxing the end of the yarn to be used to the end of the bead string and slide the beads right off onto new yarn. (See illustration.) Casting wax can be purchased at any art supply store. It is useful to wax

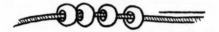

the tip of the yarn when working with loose beads because they slip on so easily, and threading a needle sometimes is a problem— it is difficult to find the exact size needle to fit the yarn and there is added bulk at the eye of the needle which often cracks the bead.

With wrong side of work facing you, work one stitch in single crochet, pull bead down to stitch just completed, and hold bead in place. Work single crochet in next stitch, pull down bead and single crochet again. Continue in this manner always working beads on the right side of your work, which is the side away from you. When you turn your work with beads facing you, do one row of single crochet. If you are working in the round, continue placing beads on the right side of your work on every round.

Leather and Fabric

Working with leather and suede requires a hole punch. Usually craft shops and leather shops carry them. You can buy just a punch with separate sizes or you can buy one with all sizes attached to

one wheel with a scissor-action handle called a rotary punch. They each have advantages and disadvantages. I use both. For small projects I use the wheel, because there is nothing to set up. For a large project that requires a lot of punches it is best to lay your

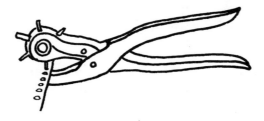

work out on a wooden board, tack it down in the corners, mark off the areas you want punched, and just hammer away. This is a lot easier on your hand. Make sure your holes are properly spaced to correspond with the width of your stitch and far enough from the edge so they don't pull out. Try making a sample up first.

After your holes are made, your yarn chosen, and proper hook selected, you are ready to start. There are three ways to add the yarn to the leather.

1. Tie a knot at the starting point, insert your needle into hole and pick up the thread on the other side, wrap around hook, and pull back through hole. Chain 2 for your first single crochet stitch and continue to single crochet across row, making sure you keep the proper tension so that your work stays flat. You may have to use a smaller hook than usual so you can fit it easily through the hole. Just keep your tension loose and your work shouldn't buckle.

2. Another method of picking up the first row I learned from a student. It was one of those happy accidents that we can all benefit from. She picked up her first row with a slip stitch, and the results were excellent. The leather has a hard-edge clean look, but be careful not to pull slip stitch too tight. Why don't you give them both a try and see which one you like.

3. Those of you who embroider already know the simple blanket stitch. Using this stitch and the yarn you want to crochet with— simply sew a blanket stitch around the edge of your leather or fabric. Don't pull too tight. Once fabric is bordered you can con-

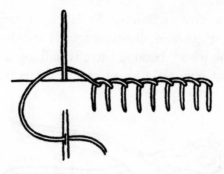

tinue to crochet with any stitch desired. The important thing to remember is to keep the leather or fabric as flat as possible so it will hang well with the yarn you are using and will not bunch up, especially around the corners.

Feathers

An old Indian method of wrapping the quill of a feather is very useful here. Notice in the diagram that a small loop is left at the end of the quill and the base is carefully wrapped for about ¾ inch before breaking off yarn. Then a clear-drying glue like Sobo is applied to the surface of the wrapped string to keep it in place.

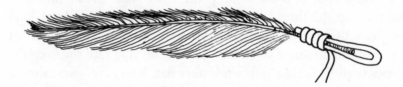

When the glue is thoroughly dry, you are ready to string your feather onto your yarn and crochet it into the work like a bead. Make sure when you string that all your feathers are going in the same direction.

Fur

Some fur from an old coat or hat, which isn't too worn out on the leather side, is still quite useful to work into crochet.

You'll need a rather strong sharp-pointed sewing needle. With the leather side facing you, make a running stitch or combination

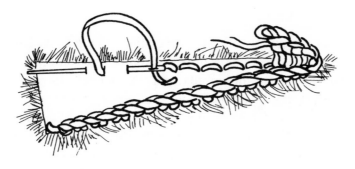

stitch along the edge or edges you wish to crochet, making stitches wide enough to insert your yarn and hook into for the next row. Pick up each combination stitch and crochet in any desired pattern or direction.

The fur incorporated into my coat collar shown in the color section was crocheted using this technique.

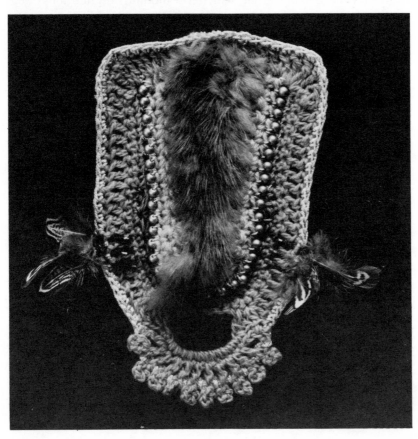

Mirrors and Other Hard Objects

Mirrors can be very effective decoration. The East Indians have been using mirrors or pieces of polished metal for hundreds of years to make their beautiful embroidered mirror cloth. Borrowing this lovely art, I tried incorporating this concept into the crochet method of working them in. It is somewhat tricky at first, but with a little patience the results are well worth the effort. First, you must use a very fine, strong yarn *without* elasticity, like speed Cro-Sheen, thin string, lamé, or anything else you can find. Use a hook suitable to this material—an E or O. In single crochet, crochet a flat round circle, the size of the mirror and on the last row (holding mirror inside circle) decrease every stitch around last row or every other stitch to pull crochet circle over the edge of mirror so that it will hold tightly in its place. This last row can be done with either a single crochet or a slip stitch, whichever method you find looks better to you and holds best. When it's finished I sometimes put a little dab of clear-drying glue on the back of the object on the crochet side to make sure it stays in place—but don't depend on the glue to do all your work. The mirror must be securely in place. This principle can be used for many hard objects of similar shape.

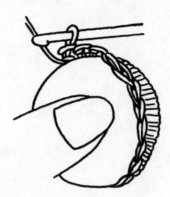

Facing page: Necklaces, Del Pitt Feldman. Top: Wool, cameo, glass, and gold wooden beads, gold metallic thread. Elaine Geisinger, owner. Bottom: Wool, acrylic, plastic, stone at neck painted by my daughter Melissa, crocheted in with metallic thread. Also included are old pieces of jewelry.

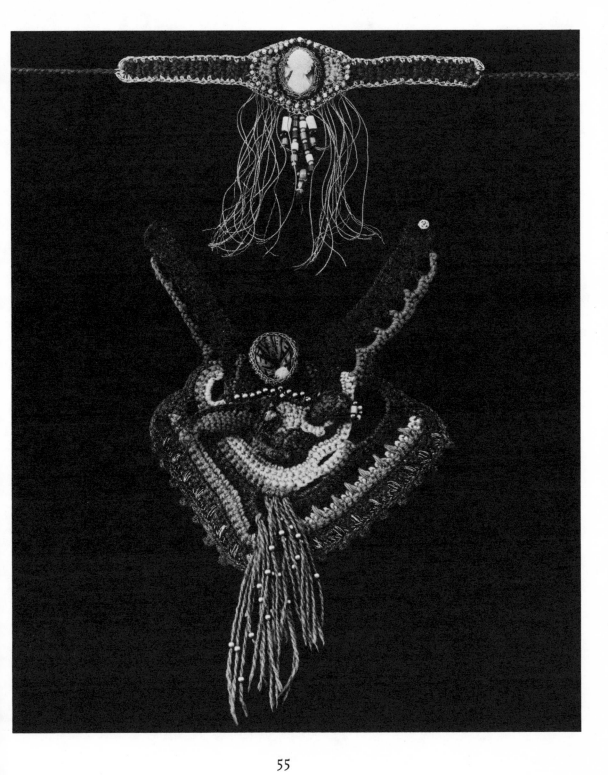

Cylindrical Form

Materials: Use strong heavy fiber with body and a hook you feel comfortable enough with to insert into yarn and which gives tight tension.

Method: With a chain of any length for the circumference of the piece (since this is a practice piece, a seven- or eight-inch chain is good enough), join with a slip stitch, making sure not to twist stitches on chain. Work around in single crochet (later you can try other stitches) until piece is a recognizable cylindrical form about one or two inches. Divide work in half and put a marker at each end. Increase at each marker for as many rows as desired, making sure to count how many increase rows you make. (On the diagram, each increase point is indicated with an X.) Now decrease at each marker point for the same number of rows until you are back to the number of stitches you began with. (Decrease points are marked with an O.)

Using this principle of increasing and decreasing in an even amount of rows, continue to add markers two at a time until every stitch is an increase. Make sure to come back to the original cylindrical form for at least an inch before adding each new increase, so that you can have a clear view of what your increasing and decreasing is achieving. You can also alter the increasing pattern by increasing and decreasing on every other row or every third row to get a more oblongated effect.

Now that you have achieved a cylindrical form with open ends you can also close your ends in one of two ways—depending on your goal.

For a flat end: Crochet a flat circle until the circumference of the circle is the same as the opening of the cylinder. Single crochet along the two edges to join, or weave two edges together with tapestry needle.

Cone-shaped ends are shown in the photo on page 58 of "The Happy Houses." For this effect, pick up stitches at top or bottom of cylinder and gradually decrease until piece comes to a point.

You can also stuff your piece before closing the last end.

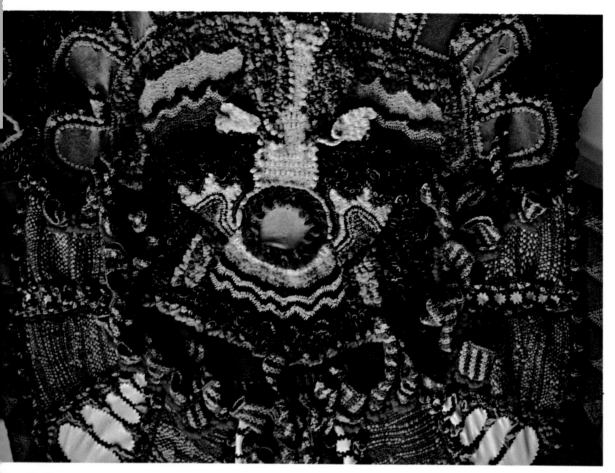

Detail, "Lucretius and
ҡusta," wall hanging by
Janet Decker.
ollection Mr. and Mrs.
ᴐhn Bennett, Toronto.

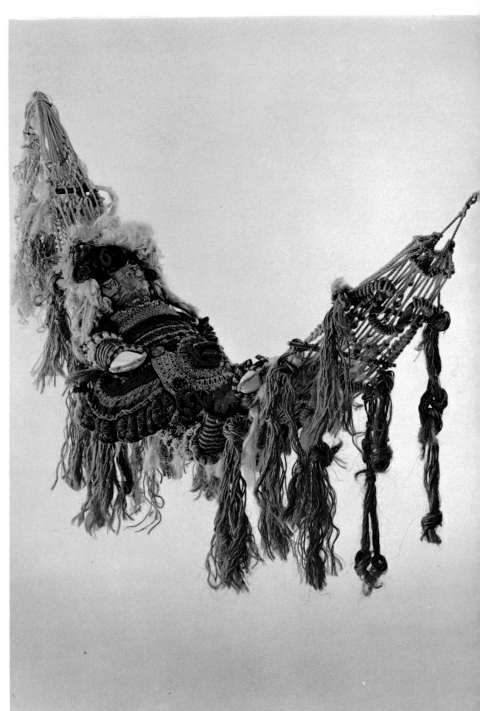

"Griselda," Janet Decker. Permanent Collection of Sheridan College School of Design, Toronto. (*Photograph by P. Ben Hogan.*)

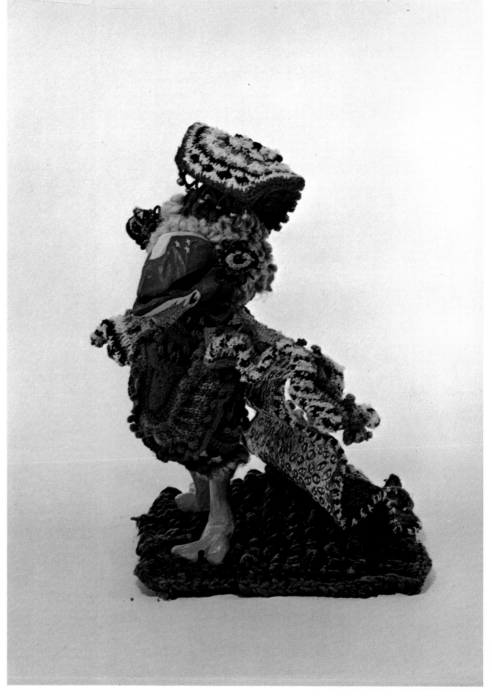

"Alcesta," Janet
Decker. Permanent
Collection of Sheridan
College School of
Design, Toronto.
*(Photograph by
P. Ben Hogan.)*

"Hanging 101,"
Toshiko Horiaki.

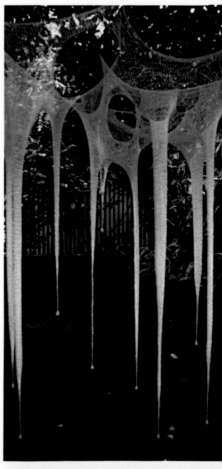

"Climb, Lie Down,
Tumble, Roll,"
Toshiko Horiaki.

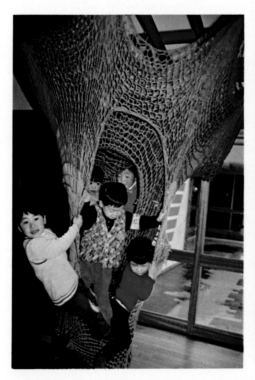

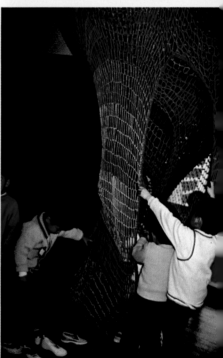

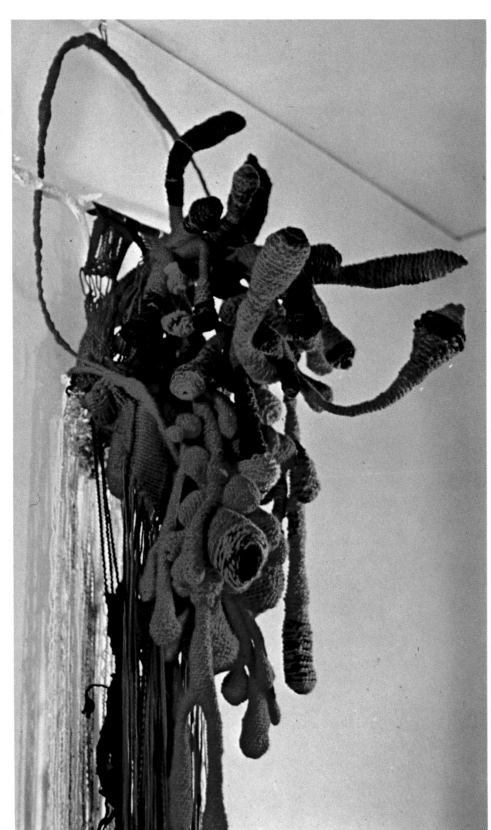

"Journey in Three Stages," Verlys Tarren Reese.

Wall hanging by Walt Nottingham.

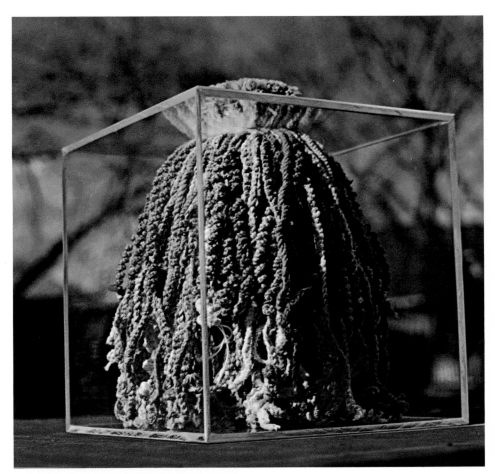

"Silence," Camillo
M. Capua.

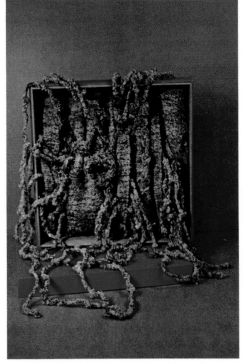

"Orange Box,"
Camillo M. Capua.
Mexican hand-spun.

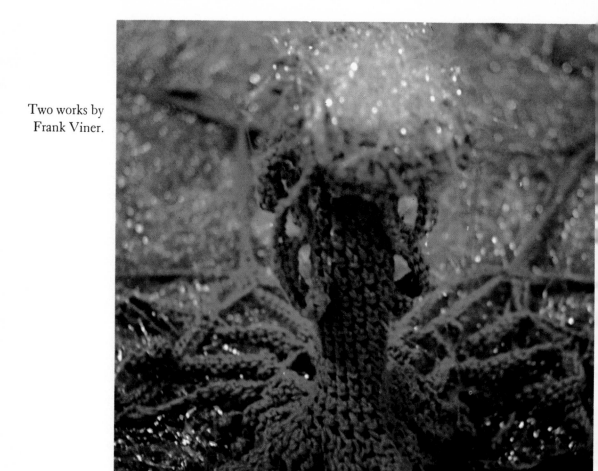

Two works by
Frank Viner.

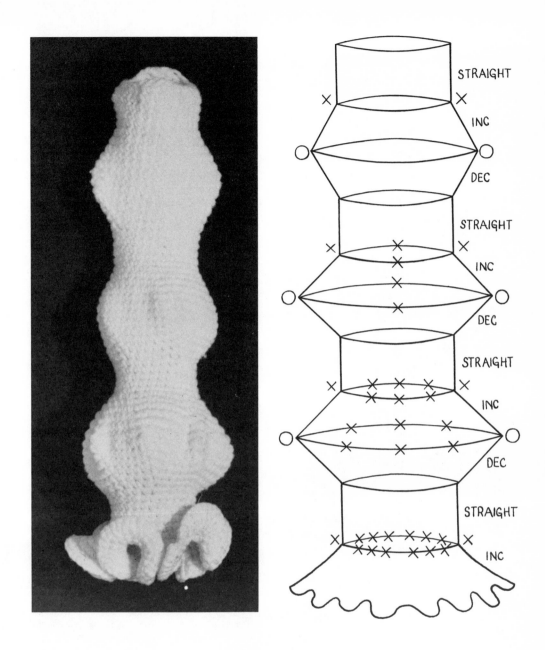

STRAIGHT

INC

DEC

STRAIGHT

INC

DEC

STRAIGHT

INC

DEC

STRAIGHT

INC

"The Happy Houses" by Nicki Hitz Edson show simple cylinders in combinations with other forms. (*Photograph by Malcolm Varon.*)

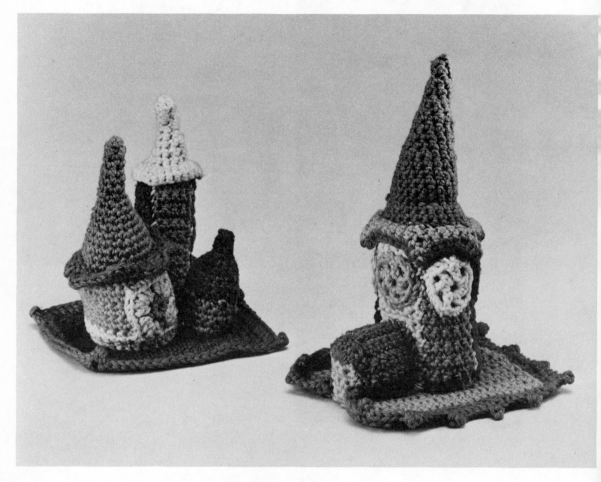

Facing page:
A full view of Judy Kleinberg's cylindrical basket construction, shown in close-up on page 27.

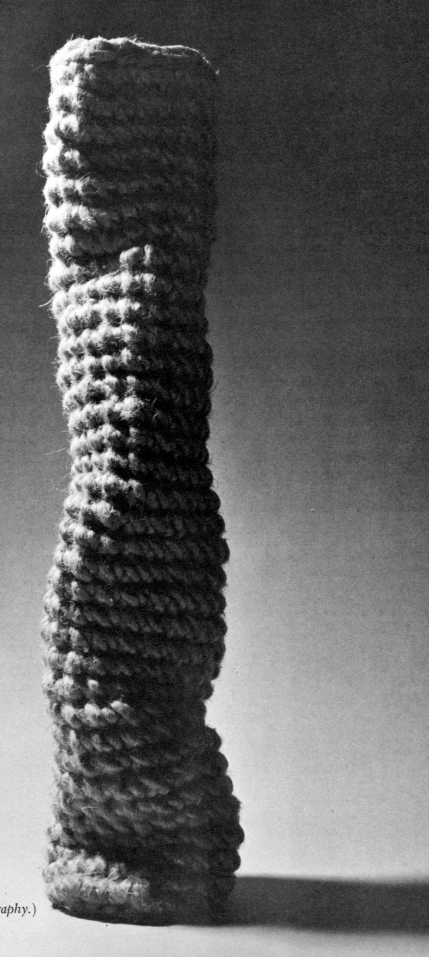

(Royal A. Lyons Photography.)

Wall Hanging

This small wall hanging is something you can try to do with various textured yarn you might have lying around. Choose your colors and textures carefully. Put them in a pile and see if you like the results of your selection. Add and subtract for a while to finally come up with seven or eight different fibers that will please your aesthetic sense.

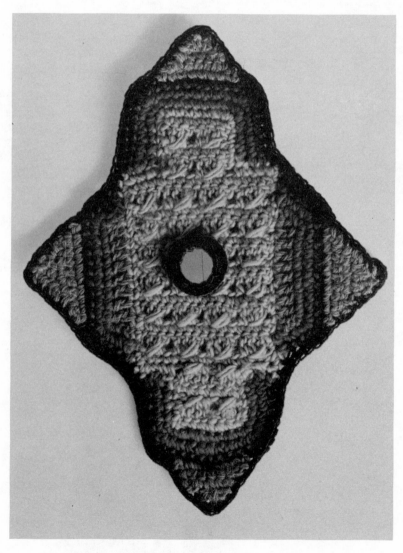

Here is how the lovely and useful Judith Stitch needed for this hanging is done:

Row 1: Single crochet into second chain from hook, 1 single crochet into each following chain; chain 3; turn.

Row 2: * Miss 1 single crochet, 1 double crochet into each of next 3 single crochet, put the hook in front of first 3 double crochet and into the missed single crochet; wind yarn round hook, draw through a long loop; wind yarn round hook, draw through 2 loops; repeat from *; 1 double crochet into last single crochet; chain 3; turn.

Row 3: Single crochet back.

Row 4: Repeat Row 2.

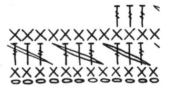

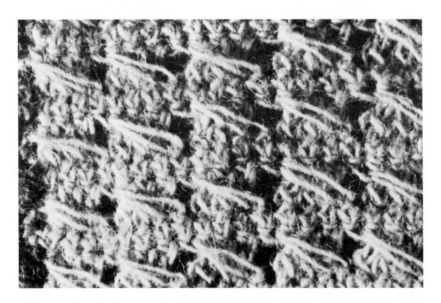

Continue in this manner until you have 6 rows of Judith Stitch. Be sure to end with a single crochet row.

Start with diagram 1: At lower right corner, start your 19 chains (indicated on diagram by small circles, o). Single crochet into third chain from hook and single crochet (indicated by an X) across rest of row. Chain 3 and work the Judith Stitch on next row.

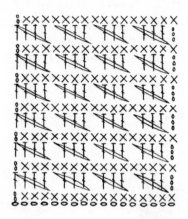

Diagram 2: Pick up 8 stitches at center of work. Work the 4 rows of Judith Stitch ending with row of single crochet. Turn work upside down and repeat.

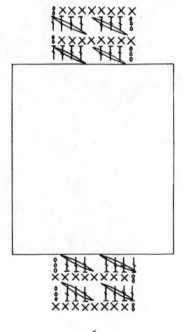

Diagram 3: Work 1 row of single crochet around entire piece in another texture and/or color to border form. (To keep corners squared off do 3 single crochet in same space at point A–H.)

Diagram 4: Pick up 13 stitches and work in double crochet at each side of form.

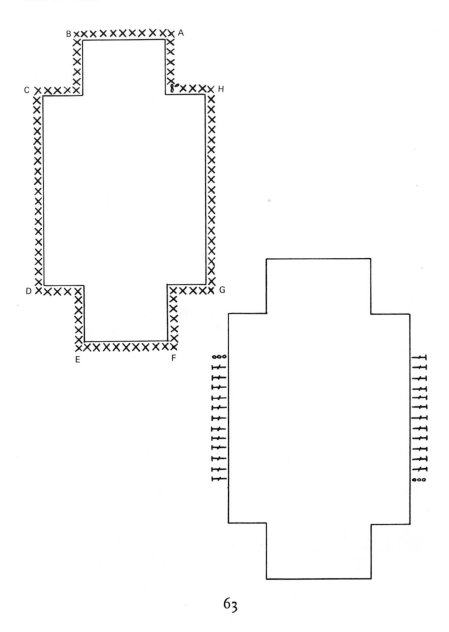

Diagram 5: Border in new texture and/or color at top and sides of piece in single crochet. (Repeat increase at corner points A–H again.)

Diagram 6: Repeat diagram 5 in another texture and/or color.

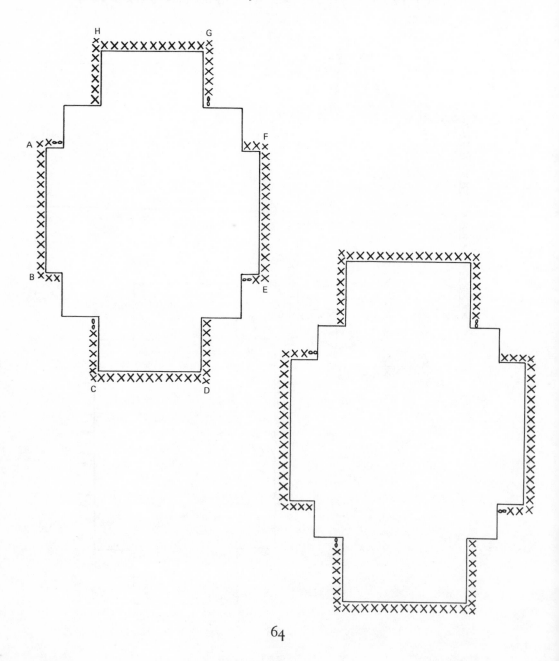

64

Diagram 7: Border in single crochet using another texture and/or color.

Diagram 8: Work triangle in single crochet as shown with another color and texture.

Diagram 9: Border completed form in single crochet.

Finishing: Work mirror or stone or any round object as shown in chapter on working with hand objects and sew onto center of completed form. You can now trace your piece onto a sheet of balsa wood and cut it out with a razor blade. Attach an eye screw onto back of balsa wood to hang and finally cover side without hanger with any clear-drying glue and press crocheted piece onto wood. Put weight on top of piece until dry.

Using Your Freedoms

Many of my students ask whether they should always plot out a design on paper. I have no set formula. Sometimes I carefully draw out my plans and revise as I go along, or I may start experimenting with a shape and a stitch that sets off a new idea.

Try approaching crochet as painting in yarn or as a three-dimensional sculpture. Let your forms suggest other forms as you go along. Keep in mind shapes that can enhance your piece.

If you have to break some rules to get what you want, do it. I believe you must be free of preconceived patterns in order to truly create. Once the basics are understood, you can be the master of design and find that flexibility is the key to success.

Does inventiveness without technical skills count? Is innovation limited without a good knowledge of technique? Is good technical skill an advantage to being free to explore? Or is it a stop gap? Such questions have plagued me and my students through the years. To me, imagination and technical skill are interdependent in order to make the piece work. As anthropologist George Mills has written, "If it is true that the intuition of the artist is formed only through struggles with his medium, then the process of having intuitions is inseparable from the process of making them public."

I try at all times to stress knowing what your stitches can do *together with* a sense of freedom. The "doodles" I encourage my students to make are examples of freedom of direction, small experiments with that unique quality of crochet that attracts contemporary craftsmen in many fields. You can also see in them what embellishment can do for a piece. Some are studies in white, some are restricted to the simplest of forms, but embellishment can add irresistible interest to any of them.

As in learning a new language, first we learn little sections of stitchery and add color and texture to let them grow into sentences until we have explored more and more sentences—and eventually created a whole story.

This doodle was made by beginners and advanced students. I started it as a joint enterprise, passing it along from one person to the next as a freeing exercise. Somehow it is easier to be free with something you are working on that is not wholly your own. Knowing you are responsible for only a short section of work allows you to be more liberated in your approach.
Try a doodle with a friend.

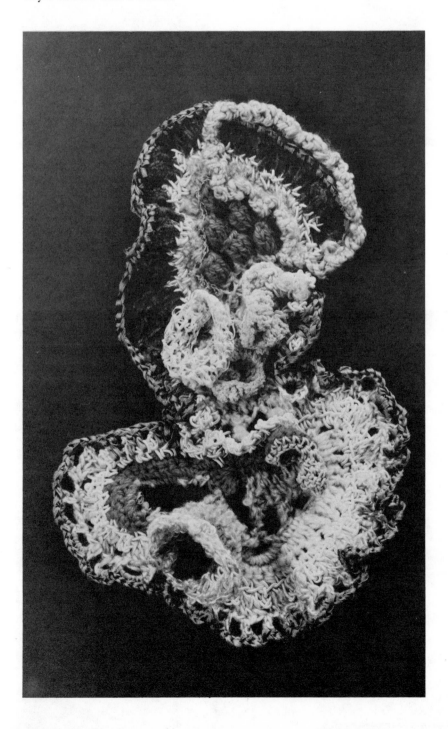

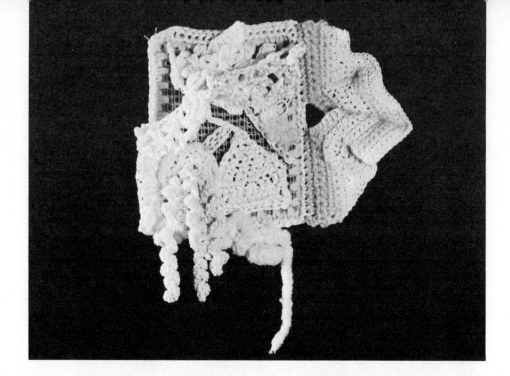

Two doodles by advanced students in the Hooker's Workshop. These doodles were made using needlepoint canvas as a kickoff point for experimentation.

We decided to keep this particular experiment in all white. However, many different textures were incorporated. Fiber like ribbon, straw, linen, wool, cord, and leather were used.

As a result of these experiments the "Surrogate Baby" was conceived.

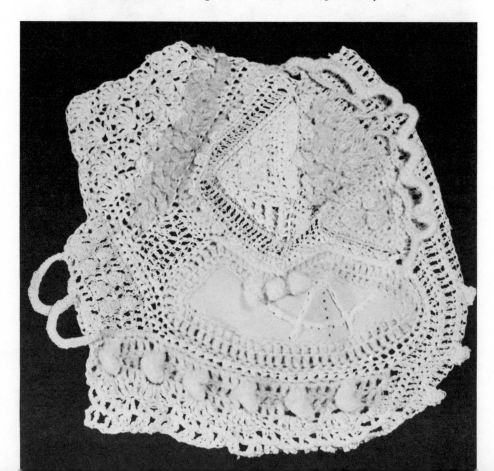

3

Contemporary Crochet Artists

Art is a creative effort of which the wellsprings lie in the spirit, and which brings us at once the most intimate self of the artist and the secret concurrences which he has perceived in things by means of a vision or intuition all his own, and not to be expressible only in the work of art.

Jacques Maritain (1882–1973)

One day some years ago, Janet Decker, a great crochet artist, sauntered into my shop to show me some of her lovely things. At the time we were both in the throes of discovery in our work, but I was impressed then and have continued to be impressed with Janet's ability to be so completely free in direction as well as color, texture, and design. I noticed a delightful, childlike fantasy had found expression in her work. A combination of hard practicality and instant imagery is there all the time. Her broad sense of the many aspects and possibilities of crochet make her work and her own statements a fine jumping-off point as we turn from abstract or general construction techniques to specific examples of artistic creativity.

JANET DECKER

Janet studied art at Pratt Institute in New York and weaving and vegetable dyeing at Penland School of Crafts. She has been crocheting since 1967 or '68 and has done macramé, knitting, and hand spinning. She knows how important it is to master technical skill

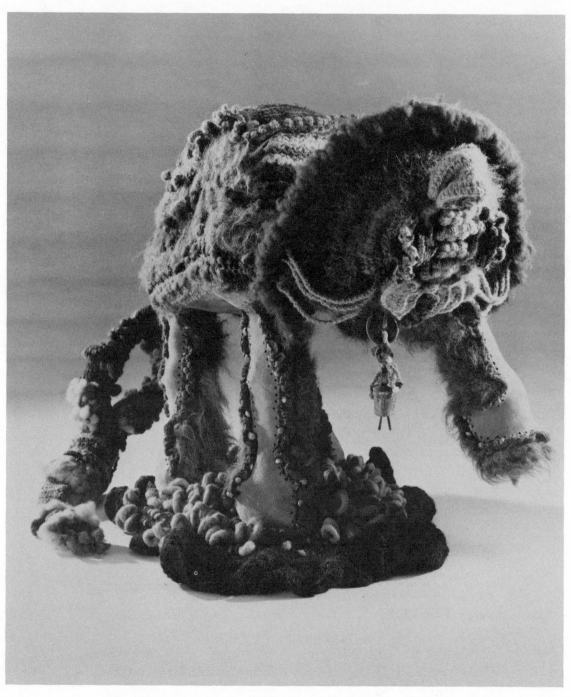

"Douglas," Janet Decker. (*Photograph by Malcolm Varon.*)

and has been kind enough to write the text which immediately follows. You will see how we differ in approach even though our goals are very similar.

To be completely free in my work is my objective. Ultimately I would like my crochet to succeed as much as it can in embodying my conception of a real-life being; for example, man or animal. Crochet has succeeded in this respect as it is virtually limitless and is easily integrated with other media. Although I am employing a craft-oriented vehicle—the crochet stitch—I am not merely dealing with design and color. I am concerned with expression via sculpture. The crochet stitch serves as the most expressive means for me. Of course this is all secondary. I can't say that I approach my work every day with this much consciousness. The work itself is all-important, and that is as it should be.

Ideally, I would always like to start with fleece—wash, dye, card, and spin it for use. However, due to time I can't always follow this procedure because I use the wool faster than I can prepare it. Thus, I mail-order various wools from England, Scotland, Denmark, Greece, and also some domestics. I try to limit my buying to whites and naturals because I do all my own dyeing.

I attempt to maintain a constantly moving palette. The climate and environment where I live have a great effect on my color schemes as I dye with what is growing—such as weeds, grasses, goldenrod, rhododendron leaves, Eucalyptus leaves, sumac—as well as whatever is available in an average household, such as onion skin, tea, coffee, and beets. I also import various natural dyeing material, such as indigo, cochineal, and madder, so that I can obtain the special effects of hard-to-get dyes—blues, reds, and oranges. Often I change a color I already have by overdyeing (topping). Chemical dyes are easier and equally as efficient, but there is something about natural dye color that cannot be duplicated. Natural dyes give you the earth, and when making a piece that embodies life this is significant. The idea of using only natural dyes is almost cliché today when people in various walks of life are trying to "get back to nature." However, here the natural process and materials *are* the most satisfying. I use wool as a building material, and the simplest way to explain this feeling is to say that natural materials

make the entire creating process more total, more absolute.

Crochet is not the primary medium; the medium is sculpture. But the fact is that the crochet stitch is the best to build with. There is always one stitch on the hook at a time. This freedom leads to a learning experience for me as I work. I have become more adept at starting at one point and designing as I go along. At the present time I draw a figure first and then crochet; then I alter the drawing as the executed crochet alters. The drawing is only the plan; the executed stitch can go in another direction entirely. I don't try to merely crochet what I draw. My drawings are very flexible plans. It is significant to note here that this is my method now. It works for my present stage and is successful since it serves as a catalytic means for allowing variation. Often I work in a modification of the "series" idea. For a long time I may deal with a certain stitch type or color relationship or row of stripes or shapes. For example, now I am working with roses and landscapes. It is also important that I explore various stitches. Sometimes different wool textures work better for one stitch than another.

ALCESTA (the duck shown in the color section)

The method for the duck is as follows. First a series of line drawings were compiled. A clay model was made for the feet and the beak, which were then Vaselined and papier-mâché was applied. The casts were dried in a warm oven. A frame for the body, legs, and head was made from chicken wire. This entire area was covered with papier-mâché except for open spaces which were left to attach the beak, legs, wings, and headdress. Then the beak and feet were sanded and painted and attached to the body. All the visible parts of the papier-mâché pieces were painted and shellacked. Papier-mâché is an excellent medium to use because a three-dimensional form can be made and painted. Its smoothness and hardness contrasts with the textures of the wools. As noticed on the underside of the wings, the "painted eye" design is akin to the fabriclike wool texture.

It was exciting to do the duck, which I call "Alcesta," because I had to work with crochet in relation to a skeletal form of papier-

mâché. Some of the crocheted areas were done separately, always keeping in mind their placement. Other areas were crocheted directly around the form very much like dressing a little doll. I was able to experience placement of shapes and forms because of the duck's definite structure. The panels for the wings were done separately for best execution of the curves and form of the wings. Because of the shape of the wings I was forced to create an utterly new design, which would enhance their movement and effect. Later this panel was sewed onto the papier-mâché wing form. The headdress was made in two separate pieces—front and back—and placed over the headdress form. This was later adorned with beads and bells. The head was approached similarly. I used raw flax to give a bubblelike effect to the head and face. The beak moves, and someday I'm hoping he'll talk to me. A long thin leather strip was used as a foundation for the structure of the eye and a bead crocheted in to complete the eye. After the bird was assembled, his hollow legs were filled with plaster of paris so as to secure him to the base. Finally the base was covered with the grassy, dirtlike green and brown wools.

At a distance, the textures and designs fade and recede, but line color and form take on the movement of the piece. These aspects transcend decoration; these are what give him life.

USEFUL CONSTRUCTION TECHNIQUES

I consider the most important thing I've learned in crochet is the ability to maneuver crochet so it can be taken in the direction you desire. The following are some specific examples. You are allowed the freedom to create any possible shape that can be imagined or drawn.

The Natural Triangle and Variations

3 double crochet in one stitch—like a small inverted triangle.

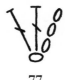

Row 1: Chain 4, miss 3 chain, and insert hook in fourth chain. Do 2 double crochet, chain 3, turn.

Row 2: Do 2 double crochet in top of first double crochet, miss 1 stitch, do 3 double crochet in last double crochet, chain 3, turn.

Row 3: * Do 3 double crochet in first double crochet, do 3 double crochet in space, miss 2 stitches, do 3 double crochet in last double crochet, repeat from *, chain 3, turn.

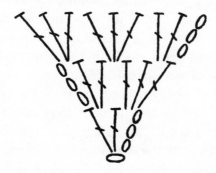

Variation ⚹1: Pulling color through color, or zigzag stitch.

Row 1: Chain 12, miss 3 chain, do 2 double crochet; pick up another color, pull through, miss 3 chain, do 3 double crochet in next stitch; pick up original color, miss 3 chain, do 3 double crochet in next stitch.

Row 2: * Chain 3 with opposite color, do 2 double crochet in first stitch, miss 2 stitches; pick up other color, do 3 double crochet in next stitch, etc. across row *.

Row 3: Chain 3 with opposite color, continue across row.

Because you are pulling color through color, the triangles are pulled close together and the effect is like a zigzag.

Variation ⚓2: A rectangular shape.

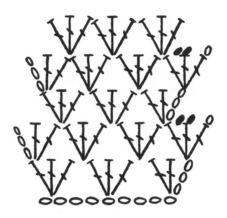

(Little triangles are always made into space.)
Chain 12.
Row 1: Do 3 triangles as described in zigzag, except with only one color.
Row 2: Chain 3, turn; do 4 triangles as described in zigzag (with only one color).
Row 3: Chain 1, turn. Do 3 slip stitches on top of first 3 double crochet. Chain 3, do 2 double crochet in same space. Continue across row. Stop at third triangle, chain 3, turn.
Row 4: Do 2 double crochet in first stitch. Continue across row as in Row 2, making 4 triangles, chain 1, turn.
Row 5: Do 3 slip stitches, chain 3, continue as in Row 4.

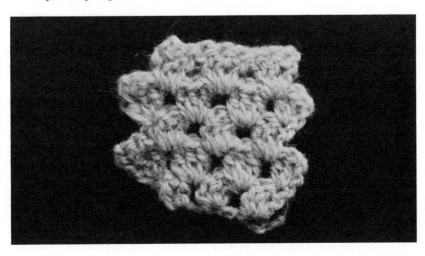

Half Circle

The wonder of crochet is that you can make it do anything you want because it can move in any direction. The following "Half Circle" is made of three different directions.

Row 1: For the base of the triangle shown, chain 15, miss first 2 stitches, do 13 half double crochet across row.

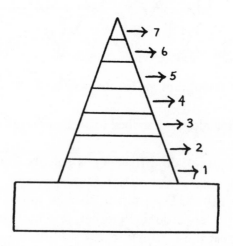

Row 2: Chain 2, do half double crochet in each stitch, end off yarn.
Row 3: Pick up new color, insert hook in fourth stitch, chain 2, do 1 half double crochet in next 6 stitches (you are now centering a triangle on the base).
Row 4: Chain 2, decrease (place hook in 1st stitch, wind yarn round hook, pull through, do half double crochet in 2nd stitch, thus giving you 6 stitches on this row).
Row 5: Chain 2, turn, decrease, leaving 5 stitches, continue decreasing in this manner until 1 stitch is left.

Now attach the same color as the triangle to the base of the triangle (increasing) at base and at top of triangle—so it will lie flat. An exact number of decreases cannot be given as a variation in wool, hook, or tension will cause the number of increases to vary. (See diagram top of next page.)

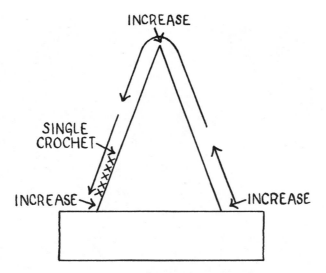

Using half double crochet after first row, continue around the half circle until it is the size of the base—always increasing where it seems necessary to allow the final form to lie flat. Just judge with your eyes an even distance in when you do your first row of single crochet around the triangle.

Never attach curved crochet to the base as it will not lie flat then. I recommend sewing when two different directions of crochet are going to be attached.

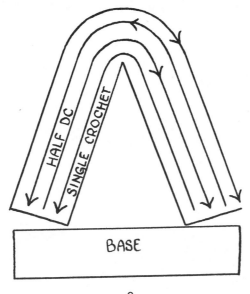

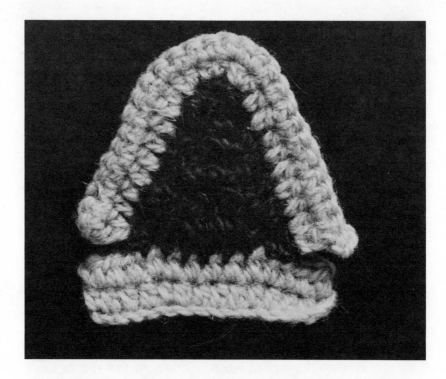

When this has been completed, fold the top part of shape over base and sew with overhand stitch the top to the base. Be sure to catch the heads (tops) of the base stitch when sewing. You use the color thread of the base.

Note: Never knot your yarn when sewing. It will then cause a small lump. Instead, catch the end of your thread as you sew.

In addition to the color plates, a hood by Janet Decker is shown in black and white on page 34.

TOSHIKO HORIAKI

A graduate of Tama Fine Art College, Tokyo, where her major was Textile Design, she also acquired an M.F.A. at Cranbrook Academy of Art in Michigan in the field of Fabric Design. Since 1963 she has worked as a fabric and textile designer and has taught in both the United States and Japan. You may have seen one of her wall hangings in the Museum of Modern Art's traveling exhibition in 1969—or in interior design magazines.

Toshiko has been crocheting since childhood but like myself had long used the medium solely for making clothing. It was in 1965, while studying at Cranbrook, that she discovered the beauty of crochet. "I worked many different structures of fabric," she explains, "then I found crochet will create the most organic shape, which is close to nature."

She has done weaving, knitting, macramé, silk screen, batik, tie dye, and block prints. However she feels many discoveries lie ahead in crochet. The actual technique involved gives her the impetus for the resulting pieces. Her primary concern is the structure of the crochet and pure form—and you can see by "Hanging 101" (see page 13) worked in linen, that she has achieved that structural sensitivity of form.

The use of color in "Climb, Lie Down, Tumble, Roll," 8×10×12 feet can be seen in the color plates. Although the hangings were worked in knotless netting, I feel they can also be worked in a double or a triple crochet stitch with similar results.

(*Photographs by Lester Andersen.*)

SILVIA HEYDEN

Like Toshiko Horiaki, Silvia is both exploring form and creating larger environmental constructions; at the moment her dominant concern is the struggle to find the balance between textile and construction.

She has been crocheting for only a few years, having come to this technique almost by chance. With a background of study at the Kunstgewerbeschule in Zürich, Switzerland, she worked in tapestry weaving and picked up crochet when she found herself without a loom for a while. Since then it has offered the chance to work with three dimensions and to see the possibilities of yarn in such form, as opposed to flat weaves. She notes her fascination with the translucency of yak-hair crochet.

The piece shown below demonstrates the need for an architectural sense and "behind the scenes" know-how. Always difficult is the armature foundation for a piece such as this seven-foot-high sleeper, but Silvia has had the good fortune of working with enthusiastic architects and sculptors as she prepared for an exhibition of textile constructions in a Swiss park.

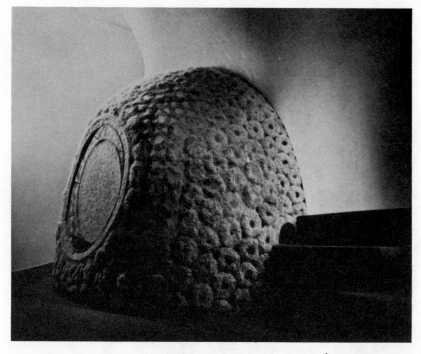

Sleeper, 7 feet high. Hand-spun yak hair crocheted in units.

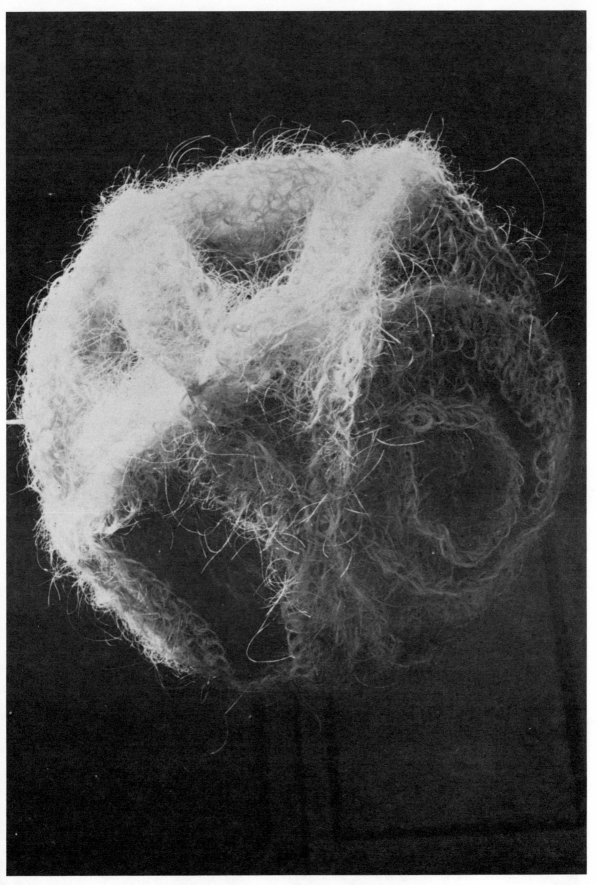

Yak hair ball, 23 inches, Silvia Heyden.

FRANK VINER

Born in Massachusetts, Frank Viner went to the School of the Worcester Art Museum and Yale University Graduate School of Art, where he received his B.F.A. and his M.F.A. He has shown his work in a mile-long list of galleries and shows since 1964, incorporating media in many directions and with show titles such as "Abstract Inflationism/Stuffed Expressionism," "Environments/Permutations, When Attitude Becomes Form," etc.

In 1962–63, Frank was making shaped canvases using found objects. At the same time he was involved in cross-indexing sculpture and painting as isolated situations. From 1964–66 his interest in new materials started to grow. He used fabric combined with silk screening overlaid on wood forms, metal, and vinyl, playing with the contradiction of these materials. His first major piece involved vinyl sewn together covering a forty-foot area and brought to fruition his first piece of wearable sculpture, a plastic jacket screened with the same pattern which appeared on a larger sculpture. By 1967 he was experimenting not only with vinyl, but with plastic tubing, aluminum tubing, black lights, and tetrahedrons.

In the past few years Frank's interest in crochet has developed to the beautiful crescendo seen in his photos in the color section. They show the conflicts of space, material, and light inherent in the visual arts. He is at present teaching, at the School of Visual Arts, a course on Fabric which emphasizes the uses of sewing, crochet, knitting, and weaving finished pieces. The jacket here demonstrates his very own approach to the functional object.

Man's coat, back view. Cotton string.

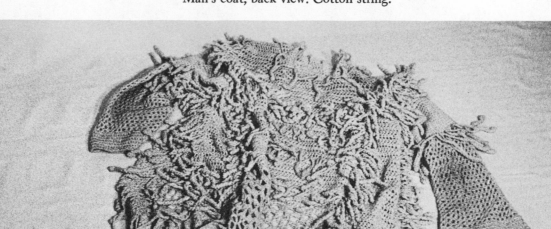

"Mannequin #2,"
Del Pitt Feldman.
(All photos in this
section by
Malcolm Varon.)

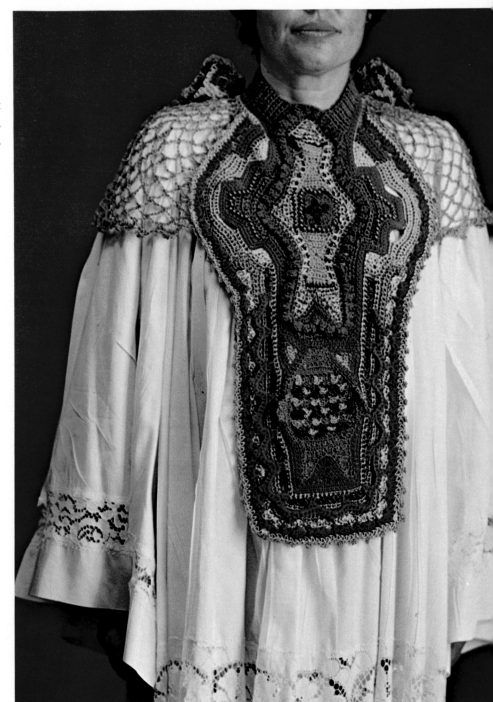

"Chausible," front
and back views,
Del Pitt Feldman.

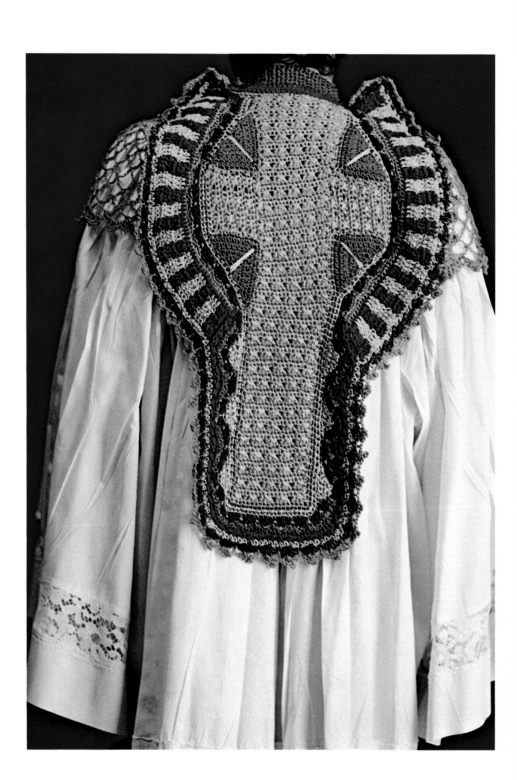

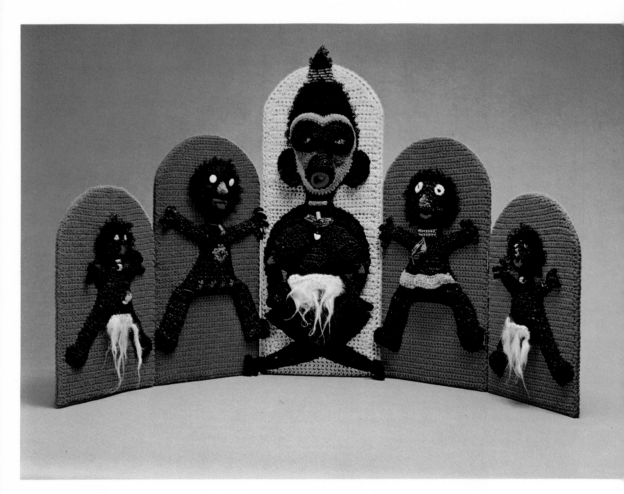

"Quintych,"
Del Pitt Feldman.

...oat worked with wool, metallic yarns, incorporating wooden beads, ...d precious stones and lace, bronze bells, fur tails, piece of old crochet lace doily, Del Pitt Feldman.

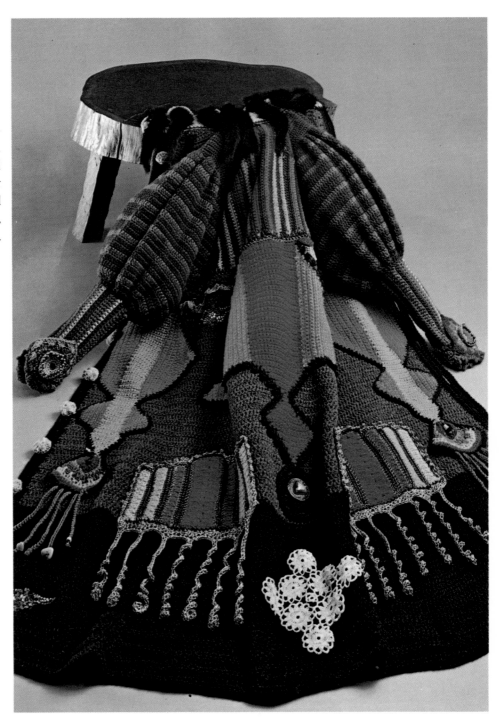

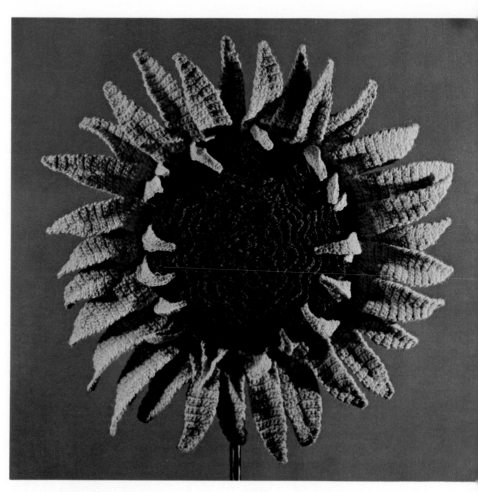

"Sunflower,"
Del Pitt Feldman.

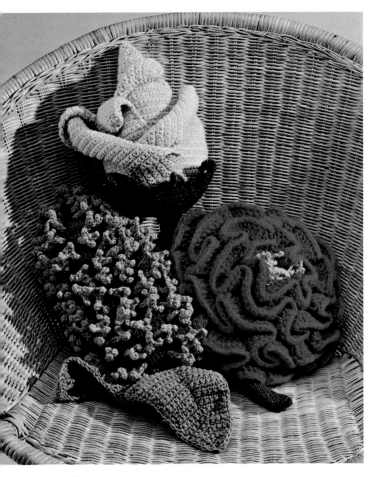

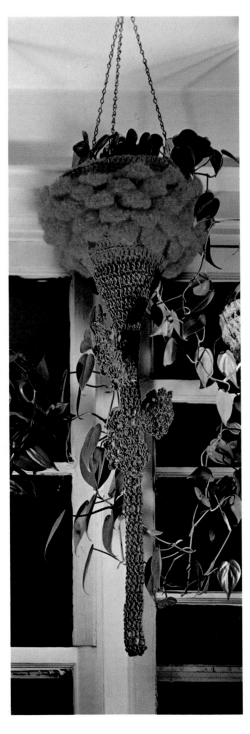

Flower pillows and
planter,
Del Pitt Feldman.

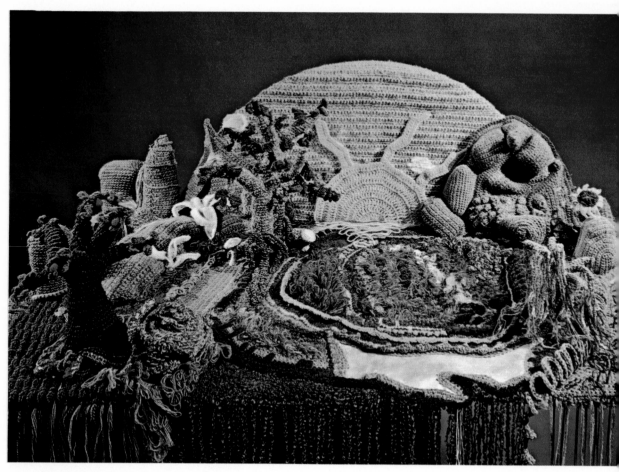

"Landscape #2,"
Del Pitt Feldman.

JUDITH I. KLEINBERG

On a trip to Berkeley, California, I had the happy experience of meeting and talking with Judith Kleinberg, a beautiful woman with a great deal of ingenuity in her work. Her use of thin copper wire is very exciting and shows the daring exploration of the medium mentioned in the previous chapter.

Judith studied at the Department of Design of the University of California at Berkeley. Before she learned to crochet she did considerable exploration with three-dimensional macramé forms, typically small, dense textures, all quite experimental in nature.

Detail, crocheted wire construction for shadows. (*Royal A. Lyons Photography.*)

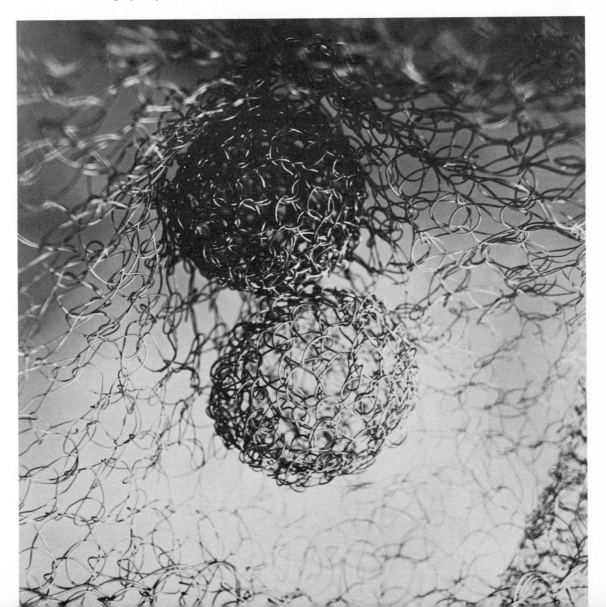

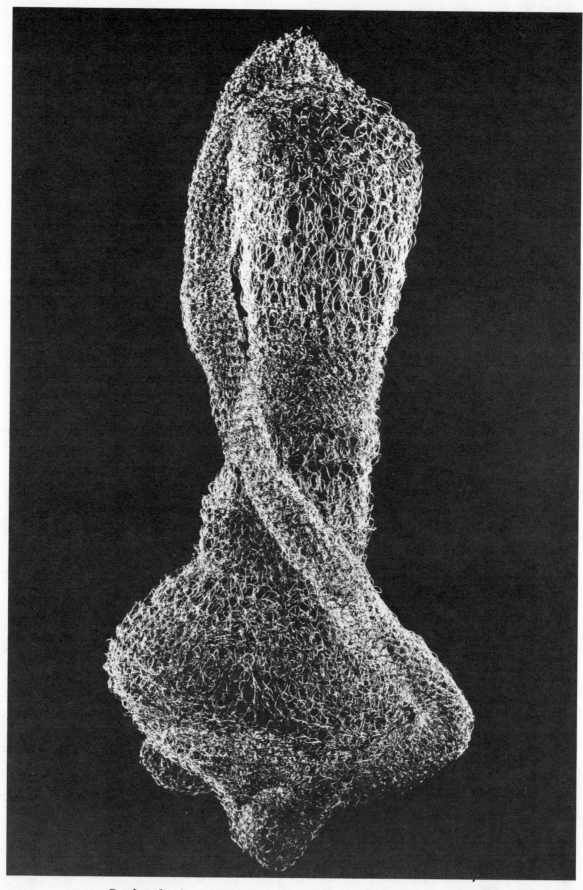

Crocheted wire construction for shadows. (*Royal A. Lyons Photography.*)

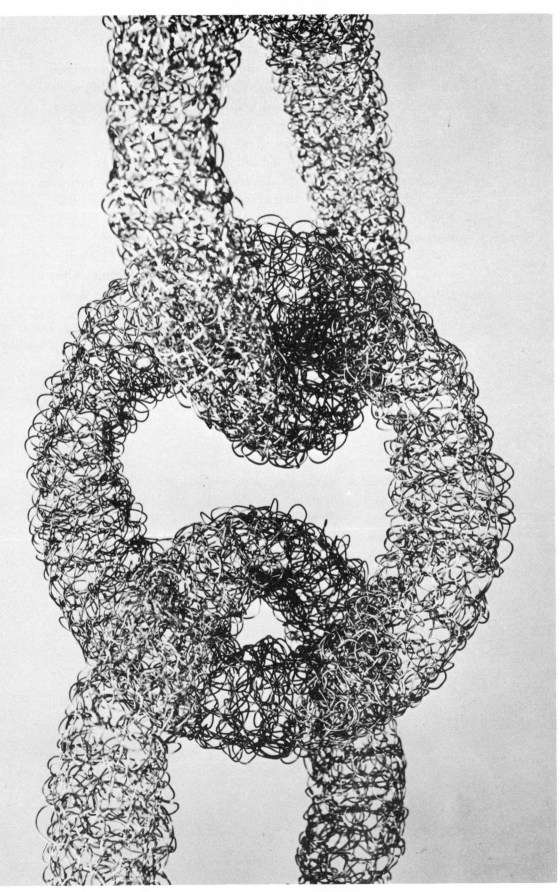

Crocheted chain links. (*Royal A. Lyons Photography.*)

Later she found that she could translate these forms into crochet and continue experimenting at a much faster pace while still achieving interesting forms and textures. The single-element construction was much less tedious. Other media she has worked in are weaving, netting, ceramics, wood, and some metal.

She is exploring many possibilities and feels that her work is very experimental. She seldom devotes all her energies to a single theme. Judith does say, however, that "form has always been the essential element in my work. I have given some consideration to texture, especially in my work with wire, but I am more concerned with *overall* textural quality than with any decorative effect. Color has played only a minor role and is usually within the natural fiber range. I frequently begin crocheting with a fiber I've been thinking about—but with no goal whatsoever in mind. The forms express themselves and develop out of some subconscious pool of ideas. This spontaneity is for me one of the most attractive qualities about crochet."

Her own articulate description of the 36-inch-long "Crocheted Wire Construction for Shadows" reveals how her responses and interests are implemented: "This initial wire construction consists of a continuous, essentially tubular form which is meant to be suspended vertically. There are three movable crocheted wire balls inside the tubular shell. The piece evolved very naturally as a response to a textile project in which the shadow or silhouette was the principal element. The soft wire allowed malleability and responded uniquely to the textile technique of crochet while allowing considerable variation in shadow form through the involvement of motion, multiple light sources, depth and layering of crocheted surfaces, as well as varying densities of textile layers. While I still find the form itself somewhat odd, the shadows are tremendously exciting and suggest a whole range of possibilities in work with wire."

SHERRY COOK

Sherry Cook has been a student at Penland School of Crafts, University of Wisconsin, and has worked with the crochet artist we will soon meet, Walt Nottingham. Before that she studied art at Cleveland Institute of Art for two years.

Her background in other fiber crafts include stitchery and weaving. She chose the crochet medium for the freedom of developing form but says that texture, color, and form must work together, each emphasizing the art statement; one is not more important than another. Sherry's approach is akin to Jane Knight's in that she too finds that the idea for the piece determines the technique rather than vice versa.

In wonderful tones of purple, her wall hanging uses wool yarn and hand-spun wool and jute. The stuffed tubes clearly attest to a well-executed plan.

Wall hanging, wool, 10 feet long.

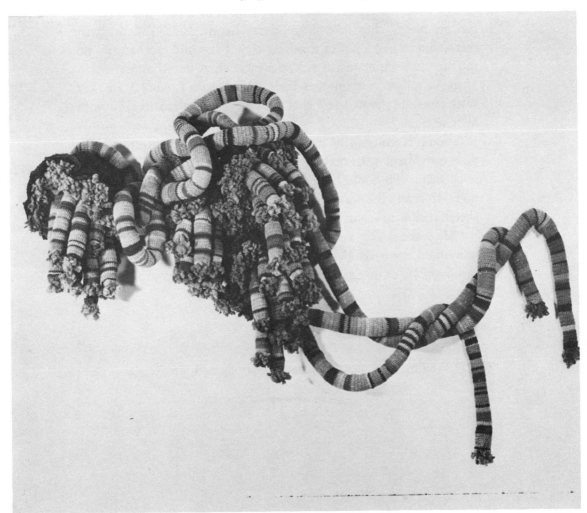

HIROMI ODA

Hiromi Oda was a student at Cranbrook Academy of Art and has been crocheting for four years. Weaving and macramé have also been a part of her work in crafts. When nineteen she attended the Kurashiki Institute, for an intensive year's study of functional weaving. Moving to Boston introduced her to non-functional areas of that craft, led her to study at Haystack and eventually to the attention of fabric designer Jack Lenor Larsen and crocheter Walt Nottingham, who recommended her for Cranbrook. Since those days, she has had several important shows. Now back in Japan, she has been sharing her sense of freedom with appreciative students and making inroads with experimental work in tradition-minded Japan.

She chose crochet because of its technical freedom. "I like working with my materials because I can move with rope and sisal and straw. Weaving by loom is two-dimensional; it doesn't involve me—my physical body—as much. When I work I like to feel I'm part of what I'm doing. That's why I work in three dimensions—I feel my pieces; they take shape in my hands; I mold them, twist them, almost like a potter touching clay. I sew and crochet and tie my rope in such a way as to feel what comes out is an extension of me—another arm, another body. What I do is what I am, my work gives me shape. I feel that my crochet form has to grow with my emotions."

Hiromi is constantly exploring and is more concerned with pure form than with texture and color, which she feels could destroy shape. To quote her once again, "Sometimes it takes me all night to get it the way I want. Inside, I feel it. On paper, I can sketch it. But to realize it, that is the difficulty.

"My work is very visual; I look to create movement, emotional movement, in what I do." Shown opposite and on the following two pages are examples of the variety of ways she accomplishes this.

Facing page:
Wall hanging, woven, crocheted and knotted jute, 60×40 inches.

94

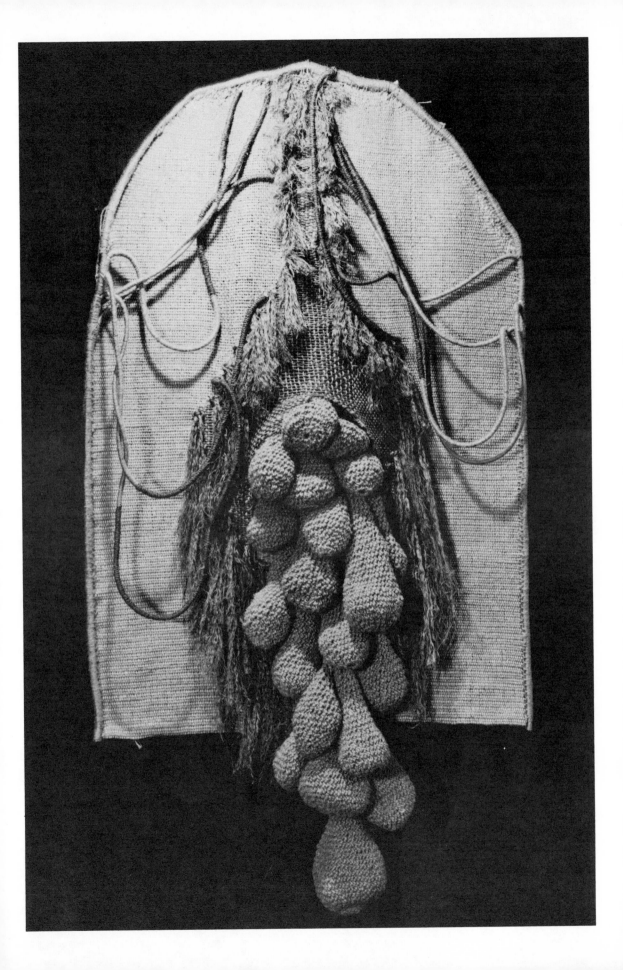

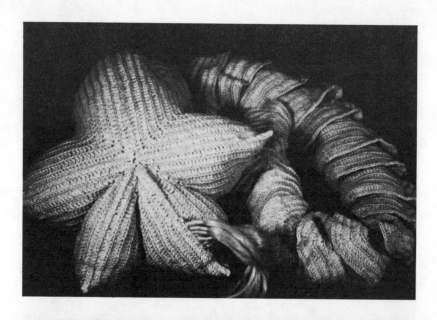

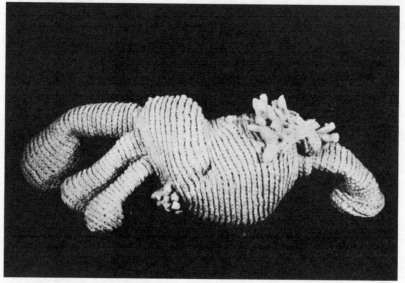

Free-hanging, three-dimensional form of crocheted cotton, 90×20

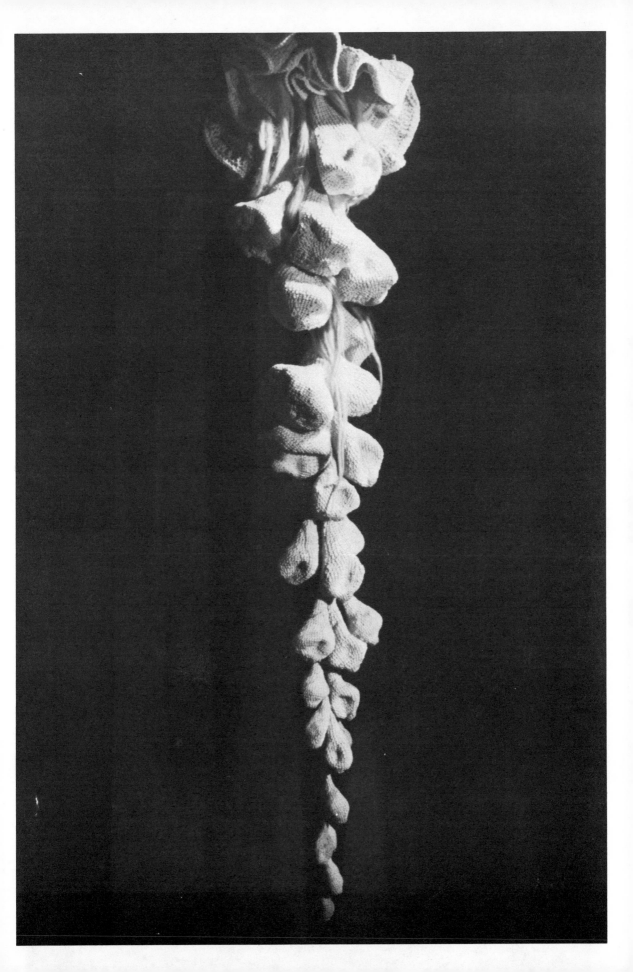

NORMA MINKOWITZ

A graduate of Cooper Union Art School, Norma Minkowitz studied at the Silvermine Guild of Artists, where she later had a one-woman show. As you can see from the photos, Norma possesses a broad knowledge of art and craft utilizing needle and yarn. She has been a designer of textiles, has worked in stitchery and appliqué, taught at leading craft centers, and won a number of first prizes, including ones from the Society of Connecticut Craftsmen, for stitchery, in 1968 and Lever House Artist-Craftsmen of New York in 1972. Her work has been shown in books and magazines and numerous important exhibits. Crochet has been a responsible field for her, and I applaud her ability to develop a unique art form which respects and celebrates the materials and the technique.

"For Women Only," crochet, knitted, trapunto, stitchery. Collection of Mrs. Kenneth Hall. (*Photograph by Kobler/Dyer Studios.*)

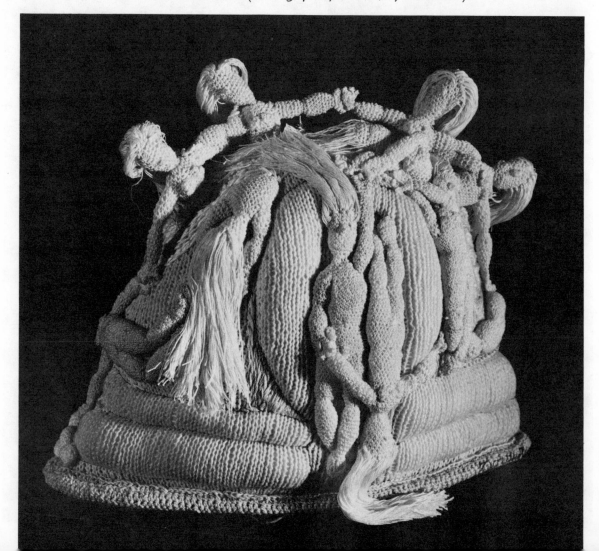

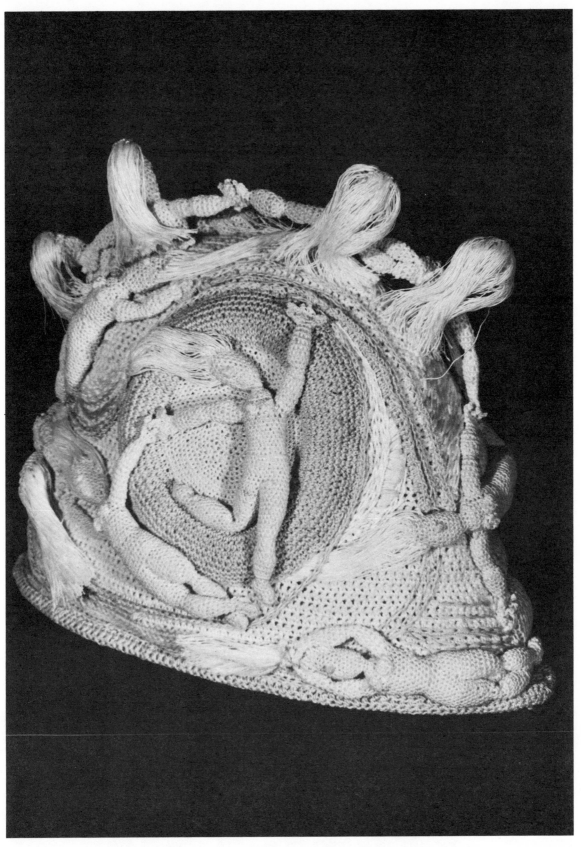

"For Women Only," other side. (*Photograph by Kobler/Dyer Studios.*)

"I feel myself drawn to the unending possibilities of fibers and fabrics," she comments. "I have the need to explore their potentials through experimentation and the combination of various forms, colors, textures and techniques. Often I am stimulated by the materials I choose, other times by a feeling, mood or idea within me. I seek a total involvement with my creations and a feeling of self-satisfaction when they are completed."

The frontispiece and page 19 show two additional works by Norma Minkowitz.

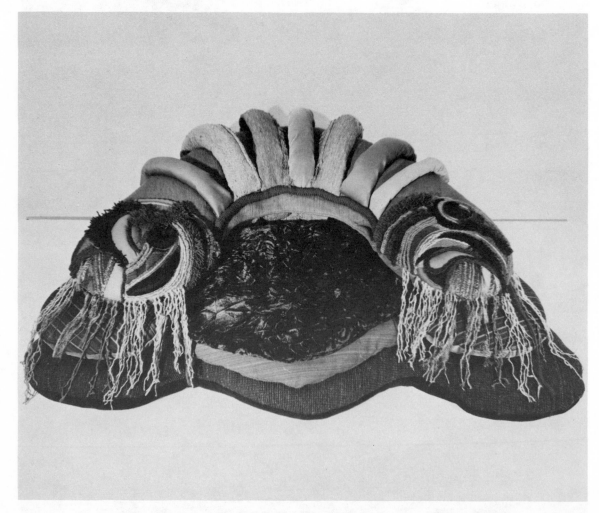

"The Sensuous Chair," 65×54 inches, crochet, padding, stitchery, appliqué. Collection, Melanie. (*Photograph by Kobler/Dyer Studios.*)

JANE KNIGHT

The precision of shape in much of Jane Knight's two- and three-dimensional work to me reveals her experience in the media of metal, wood, plaster, and clay. Her degree in design, from the University of Michigan, is well served by the fine sense of balance and detail in the pieces shown.

For about six years Jane has been expressing her ideas through the responsive and fertile medium of yarn and crochet hook. It is what the technique of crochet can do to achieve the end results she envisions that she values. The six-foot-long hanging shown in full and in detail on the following pages is an excellent example of her own creative use of the technique we described in the formation of cylindrical shapes.

Wool, 24 inches.

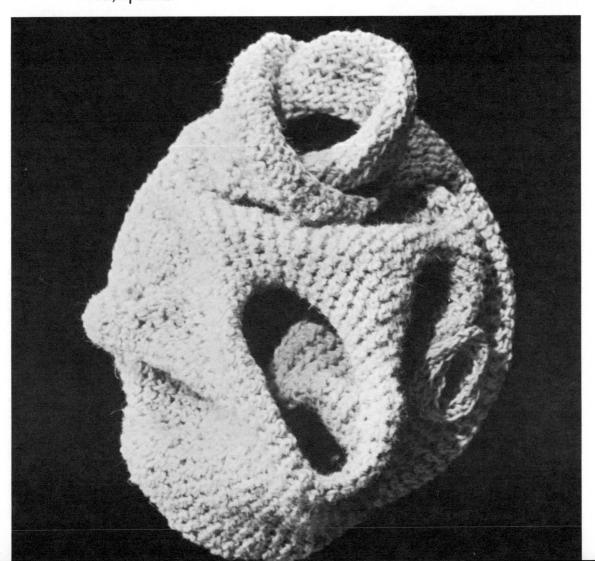

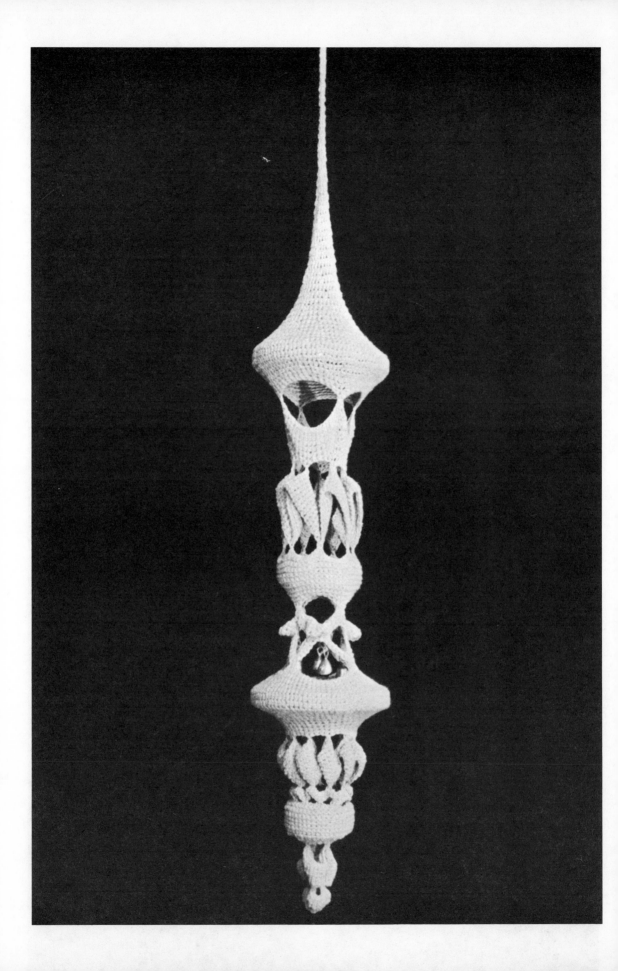

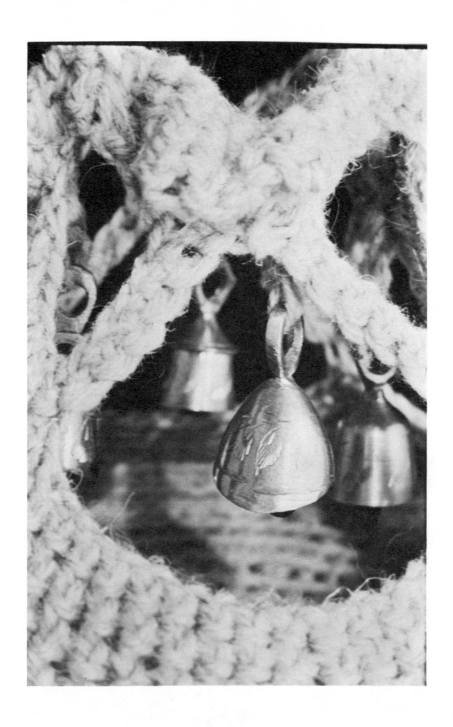

CAMILLO M. CAPUA

Unfortunately I have never met Camillo, though through his letters and work I feel a great kinship with him. His work is exciting and unique. At the same time it has a classic beauty, bold and timeless.

Camillo studied art at Cranbrook, has delved into the craft areas of weaving, knitting, and cut-work and began to crochet because it was a new technique through which he could explore fiber.

For Camillo, form is important because it is the structure or architecture of a piece. He also feels that the finished object must be pure crochet or else it fails—unless the other technique is visually clear.

Technique and result merge in his striving to convey dynamism. As he puts it, "The matrix of all things holds a fascination for me;

"Silence," linen, wool, and nylon Curling stitches and chains tied together.

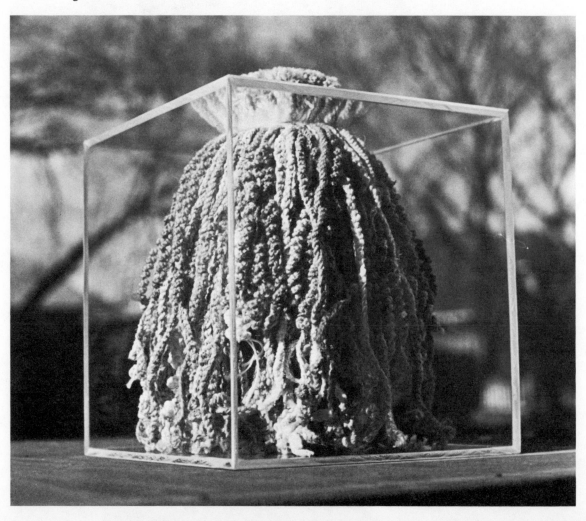

it is design. To come upon a thing and to comprehend it in terms of its physical matrix leaves its purpose free to stand or fall on its own strength. The simplicity of crochet allows for minimization and a more basic reaction. Perhaps the nicest thing is that the product is made of one strand of material, mathematically maneuvered, and remains one strand when complete. I believe this is vital, as vital as the strand that all things are made of."

The crochet object in the clear plastic box was meant to "present a loud texture in a silent way, forcing the viewer to touch it with his eye instead of his hand." " 'Self-Portrait' was a natural and pleasant way for me to speak to me about me in a medium I respect, crochet."

"Self-Portrait," white porcelain head has crocheted crown from which industrial twine was picked up.

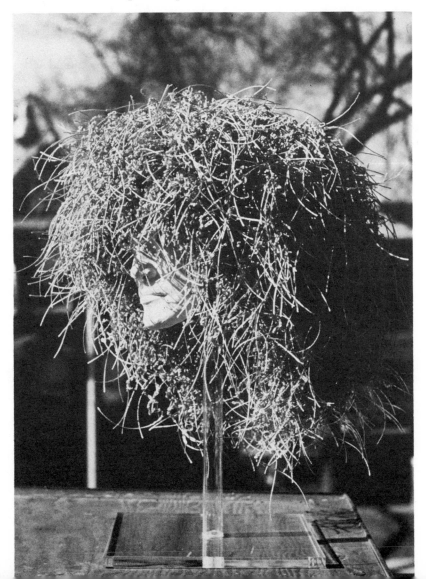

WALT NOTTINGHAM

Walt Nottingham is a very special person, artist, and teacher. No discussion of contemporary crochet could stand without including his work. Readers of my first book will recall we departed with contemplation of his "Celibacy," illustrating as these pieces do complex uses of the simple technique of crochet. The "Celibacy" hanging is included in the opening section (page viii) of this present book.

I feel he is a man of few words and a great deal of action, for his work shows great vitality and emotion. "Soul Touch" was the title of the work included in the "Objects: USA" collection which traveled through the country. In the pictorial survey of that exhibition Walt comments, "I feel pain from my world—I scream, but it does not relieve the pain. I don't know what I want, but I am constantly finding what I don't want. I search for the forms of things unknown. Fabric can and often does have within its aura a pent-up energy, an intense life of its own. I am not trying to make the visible seen, but the unseen visible."

He studied at Cranbrook Academy of Art, Bloomfield Hills, Michigan, and at Haystack in Maine, and is currently teaching at the University of Wisconsin in River Falls. In 1965 he was awarded the State of Wisconsin grant and Designer Craftsman Awards in 1965 and 1967, as well as the Fall River National Award, in Massachusetts in 1967.

He has been crocheting for ten years or so and chose this craft for its freedoms. He has worked in all other fiber construction but in his words, "I'm damned to be a weaver." However, Walt, "You're a damned good crocheter." Walt feels that he is still discovering. His goal is wedding content and form, and he is always concerned with texture and color as well as pure form. A vibrant Nottingham construction is included in our color section, and two additional pieces appear on the following pages. "Shrine" shown opposite uses wool, jute, and rayon, the latter a fiber often incorporated in his pieces. As you see he works magic with beads and feathers and techniques such as wrapping. The seven-foot-high "Shrine" intrigues while it remains subtle.

106

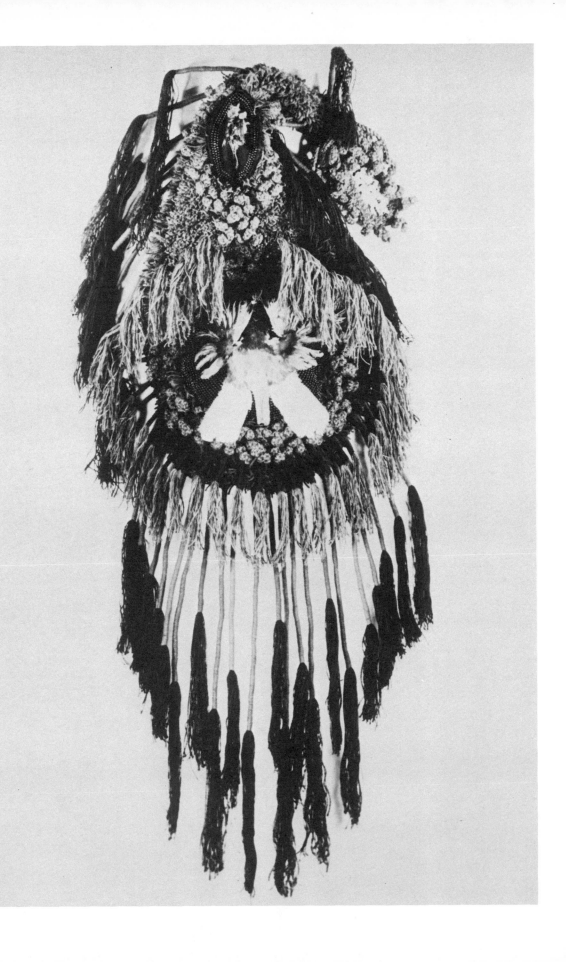

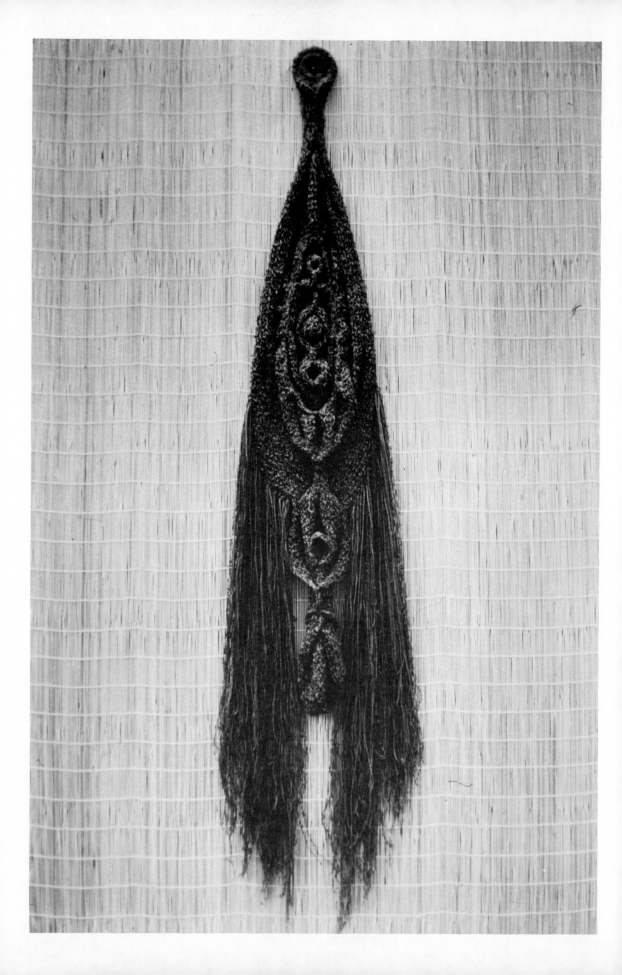

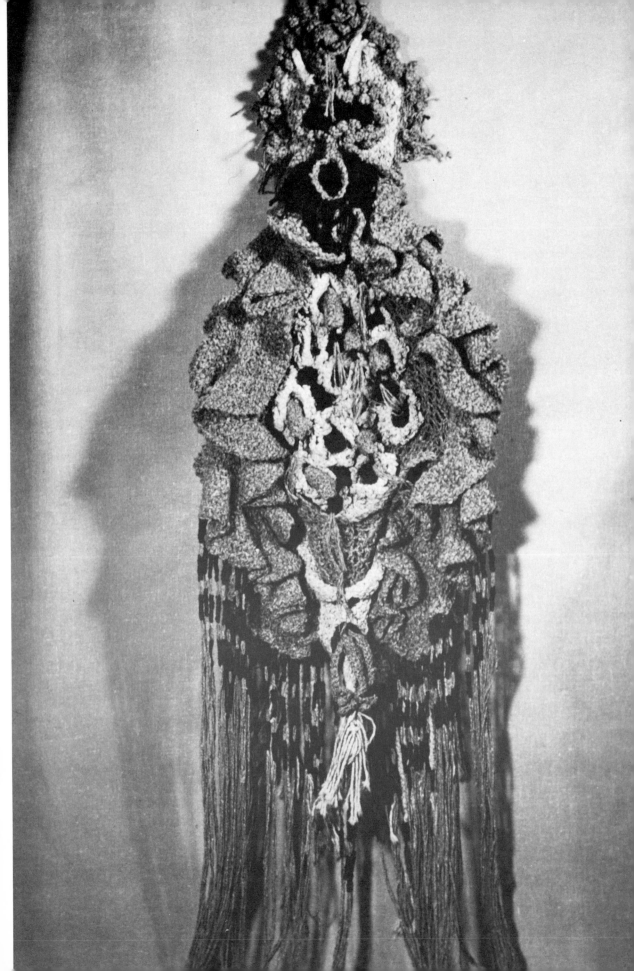

SUSAN MURROW

Co-author of a lovely book called *Contemporary Crochet,* Susan is a very dear friend.

She has studied at the Art Student's League in New York. Actually, painting was her main interest at the time, but she also dabbled in crafts like weaving and macramé. However, crochet became her greatest interest, and for the past three years she has devoted herself to the medium.

Susan says, "I love the sensuousness of the yarns and textures. Right now I'm exploring organic forms, with color being my mainstay, using textural emphasis wherever it seems to enhance the piece, or in areas where touch is important."

"Dinner," 18½×14½ inches. (*Photograph by Malcolm Varon.*)

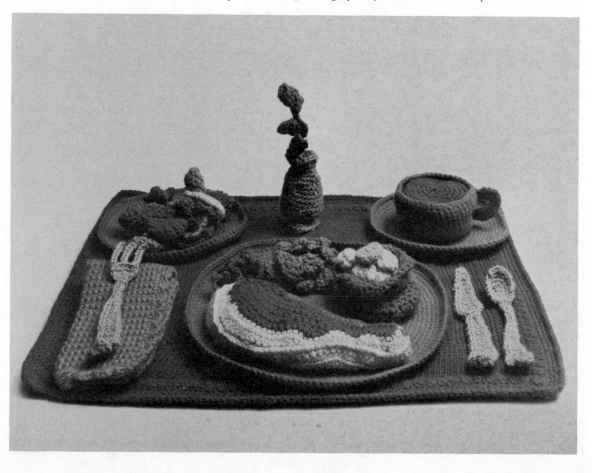

BONNIE MELTZER

Bonnie Meltzer has studied art at Montclair State, New Jersey, and the University of Washington in Seattle, where she received her M.F.A. She has also attended Haystack.

Ten years ago she started crocheting because of its limited use of mechanical devices. It is easy to concentrate on the statement and the piece rather than the details of technique.

Bonnie has worked in all the textile media, but her work in crochet is going in a figurative direction. In Bonnie's words, "I work because I have a need to make things. The finished piece as com-

"Yin and Yang," wool and fur.

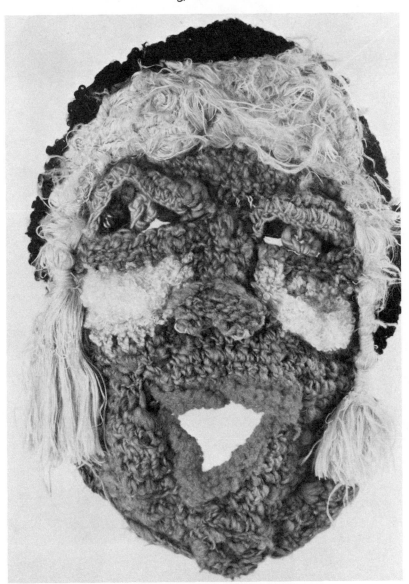

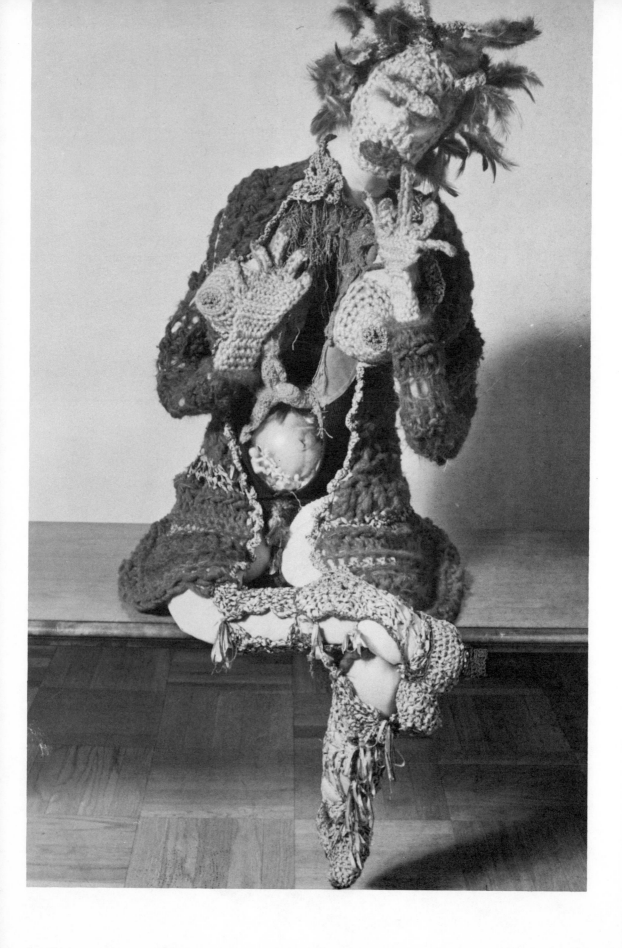

munication is the most important aspect. I mix media to get the desired effect."

Seven by twelve inches the face called "Yin and Yang" is wool and fur and is double-faced so as to be reversible. "The whole is equal to the sum of its parts" is a recent example of the many life-size figures Bonnie has done. The materials are wool, mohair, plexiglass, and ribbon. Another figure is shown on page 16.

"The whole is equal to the sum of its parts," wool, mohair, plexiglass, and ribbon. Life-size.

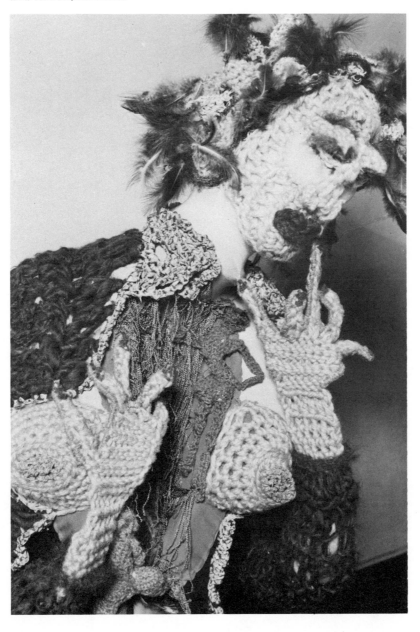

JOCELYN DE NOBLET

Jocelyn de Noblet has shown at the Galerie Boutique Germaine in Paris. A former art student who studied in Milan and Venice, she has been working with plastics and neon.

She has been crocheting since 1968 and chose crochet for its textural qualities. Her exploration of the medium is taking her into the areas of pure form.

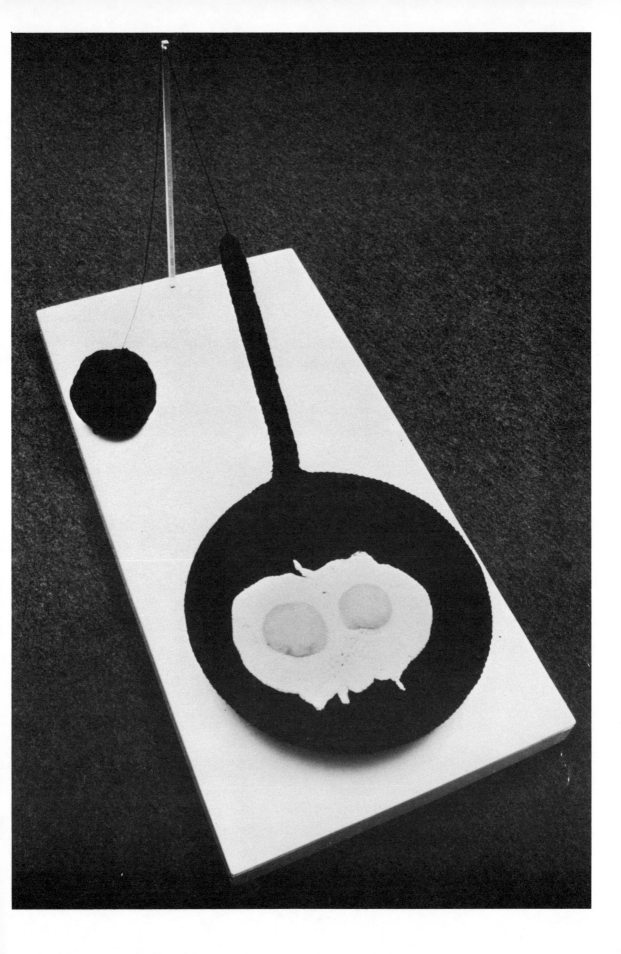

ZIZINE BOUSCAUD

Zizine Bouscaud is a very talented crochet craftswoman from France whose work was also shown at the Galerie Boutique Germaine. She has worked in fabrics and knitting and learned to crochet during the last World War by making scarves for prisoners. For her, the medium offers the possibility of expressing herself in volume as well as in a certain poetical way.

Her personal discoveries are not made in crochet but *through* crochet, and the craft gives her the most convenient way of expressing ideas and feelings. For her, texture and color cannot be separated from creation of and contemplation of the object/expression itself.

Very often when I'm working I feel as Zizine does because a subconscious response to materials leads to a sudden realization that it's working (and sometimes that it's not working).

VERLYS TARREN REESE

In her work, Verlys Tarren Reese has shown great versatility in combining various techniques into one integral force. She was an art student at the University of Wisconsin and worked with clay for a long time but found she was trying to make clay do what fiber does more easily. So she started to teach herself macramé. She's interested in the general area of fibers and likes the texture that one can get with crochet, as well as the comparative freedom one has to work three-dimensionally.

Verlys, like many of the crocheters included here, is sure she has lots of discoveries to make yet. She finds herself exploring in specific directions and says, "I'm concerned with phenomena, both within myself and in my environment that I feel or see and don't understand. My work is a kind of coding and visualization of this phenomena. A manipulation of what appears to be a chaotic manifestation into something beautiful without deviating too much from the original message. Color, texture and form come from the nature of what I am discovering and my wish to present my findings gracefully, if not beautifully. I tend to let the fiber I'm working with suggest the technique I'm to use. That it feels right, is my only concern in that regard."

Facing page:
"Journey in Three Stages," macramé, crochet, braiding, 101 × 21 inches.

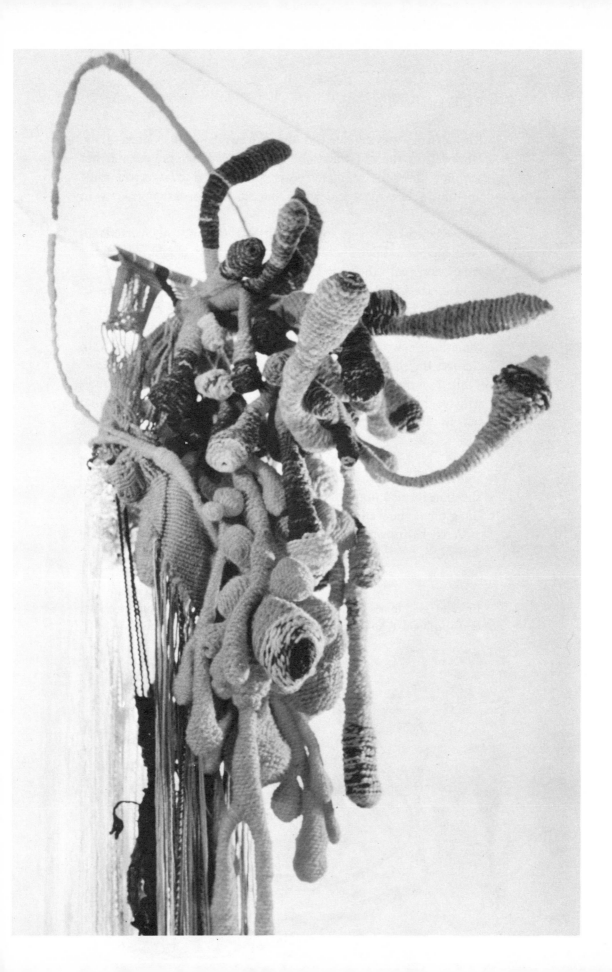

RUTH NIVOLA

Ruth Nivola was schooled at the Art Academy in Monza, Italy. However, in the old tradition, she attended her family and her sculptor husband for many years, putting her own career aside up until a few years ago when she started to design jewelry in crochet.

Needlework was very much a part of her youth in Switzerland, Germany, and Italy, where the schools routinely taught it to young ladies along with their academic studies.

Ruth feels that since each piece requires tens of thousands of stitches, it could be the worst kind of drudgery; yet every stitch is a fresh invention. A small way of turning the needle or hook puts something new into the work. The slightest relaxation of the yarn changes the shadow play of one stitch on the next.

She says that "to make something beautiful with your hands, with your trained hands, especially if it is made of material that has no value in itself, that is better than to have a diamond set in bad taste."

Ruth Nivola spent one winter at the Etruscan Museum in Rome studying its centuries-old pieces of body adornment. A true artist, she transformed appreciation of the heritage of crafts into something totally new and her own.

What better way to conclude this survey of crochet today than with Ruth's words, "Good craft is a jewel."

Bracelet, gold lamé yarn with antique metal shoe buttons, and necklace, tied and braided gold lamé. (*Photograph by Gwenn Thomas.*)

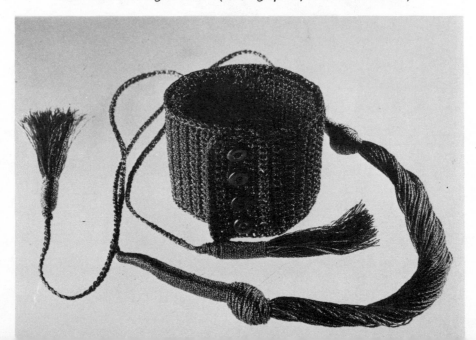

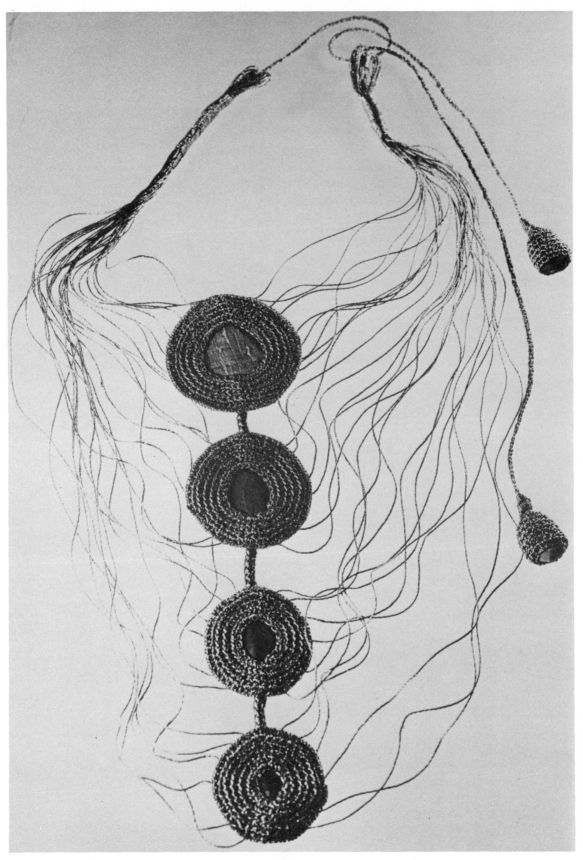

Necklace, gold lamé yarn with Oriental silk insets. (*Photograph by Gwenn Thomas.*)

4

Personal Approaches, Statements, and Solutions

The pride of the artisan in his art and its uses is pride in himself. . . . It is in his skill and ability to make things as he wishes them to be that he rejoices.

George Santayana (1863–1952)

It is becoming clearer as I work that there are definite similarities between primitive forms of crochet and the approach that I feel evolving in me. It might very well be that my new-found freedom in using the medium and my experiences with it parallel the progress experienced by natives in distant places and times, when they were first shown a new stitch. In Chapter I is a hat I made that has a very similar shape to an early African hat, and in the ensuing pages there will be other examples of past in present. Each piece, for me, gives something of the "flavor" of the craft's particular ethnic and emotional ties.

Fine craftsmanship and artistry have been signs of great respect and admiration in tribal life. Margaret Mead suggests that a craft becomes art for a people if there is only one or at least very few practitioners of it. I don't think that a special gift of hand alone is required as much as a sense of perfection and a sensitivity that drives a person in the direction of art.

My background as a sculptor has helped me in the construction of many of the pieces we will now consider. Study of the human body and designing clothing for a number of years has helped me with basic principles of form. Many skills and insights you acquire as time goes by affect your craft in subtle ways. It all has to do with developing your own signature, as we discussed earlier.

"DANCING GIRL"

Many fragments of early sculpture were found to have knitted stitches carved on the surface. The actual woven or knitted fabric may often have been pressed against the wet clay, leaving a most interesting surface texture. In any case, this idea stirred me. In all the years I worked as a sculptress, I always felt there was a lack of direction in my work. Somehow I wasn't communicating all of my knowledge and ability into the finished product. Since needlework had always been a driving interest in my life, and even afforded a means of support, I felt there must be a way to link both forces together.

"Dancing Girl" shown on pages 128 and 129 was one of my first ventures into surface texture and stitchery in a bronze. Since designing knit and crochet fashions was my occupation in 1964, clothing played a strong role in the piece. The crochet dress was made in wool and wax was brushed onto the surface, heavy in parts and light in others. You will notice that where the stitches are clearly visible, a medium application was used. Heavy application produced the shapes and added a variety of surface interest.

"MANNEQUIN ⌗2"

On one of my frequent walking tours around the city, I discovered a marvelous gallery, Tribal Arts. In the window stood a little wooden statue covered with the most interesting knitted fiber. I was told by the proprietor that the piece was a Likishi dance figure from Chokwe, Angola, and was about a hundred years old. The leader of a tribe was covered from head to toe with this knitted fiber and a small wooden doll was made as a replica of the leader, with a head of mud and grass. The actual work I saw at the gallery had more irregular forms—as shown in my own piece—but was not unlike the figures opposite with their striped design.

This incident touched off the design for "Mannequin ⌗2," which was made by crocheting simple forms right around a mannequin I had found, without the use of any seams whatsoever. It was difficult to crochet around the doll, but I felt it was a worthy

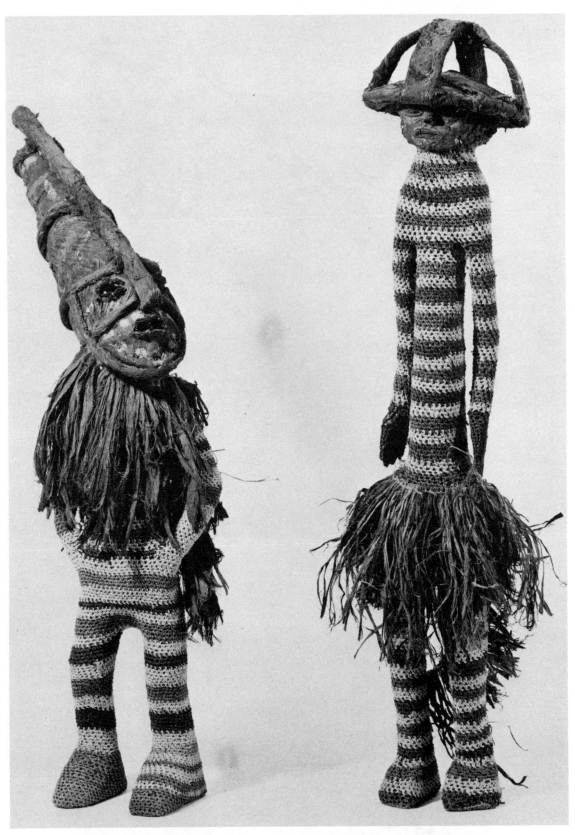

S. Congo, Bajokwe, nineteenth century. (*Courtesy of The Brooklyn Museum.*)

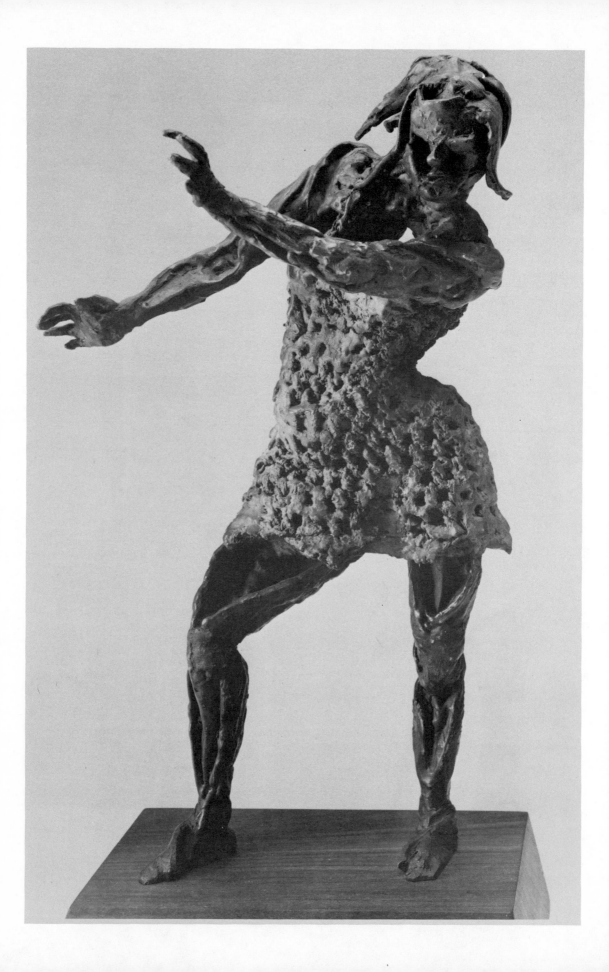

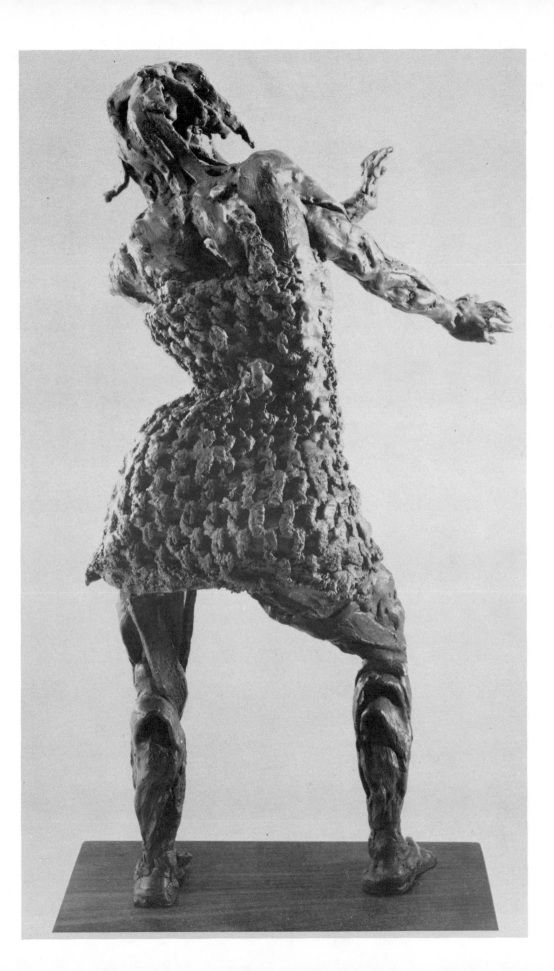

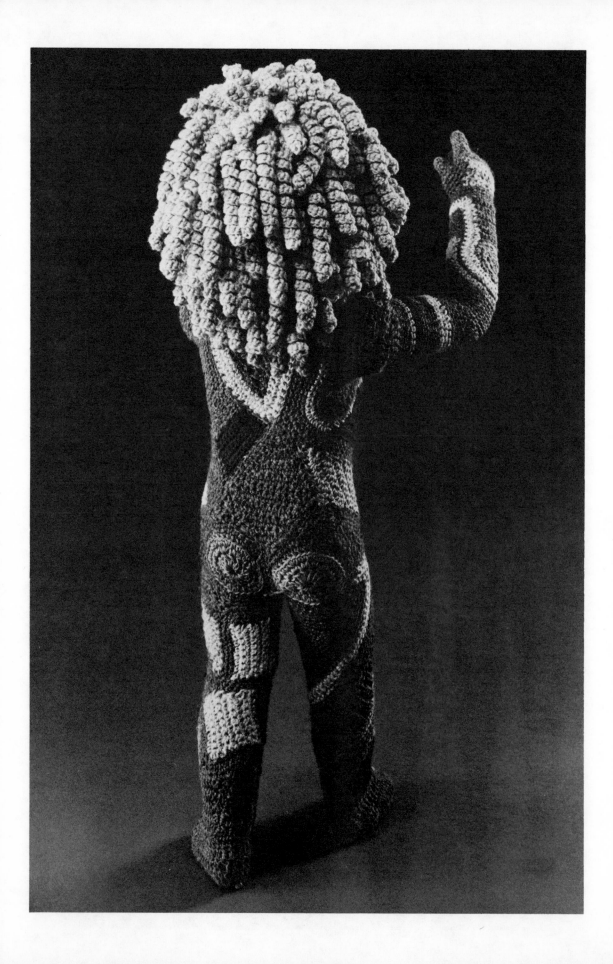

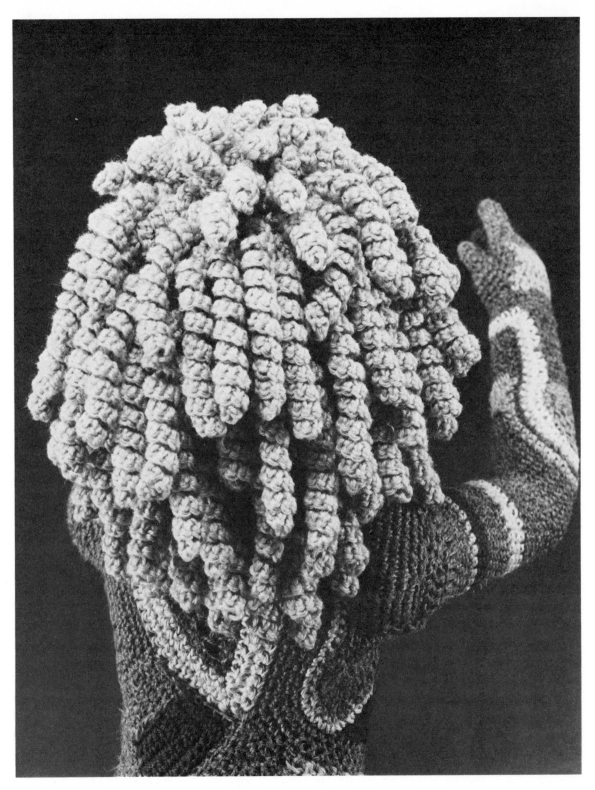

"Mannequin ⌗2"

challenge and that the forms would seem to be floating in space, as it were.

The textural interest of the hair was achieved in a series of chains crocheted in a single crochet stitch called the Curling Stitch, a useful one in crochet art.

Curling Stitch: In the first row, make a chain as long as desired (the curling will shorten the chain to a little more than half the original size of the chain). In the second row, do 2 single crochet stitches in every chain stitch from previous row.

"CHAUSIBLE"

Attending an exhibit of twelfth- and thirteenth-century religious objects at the Cloisters, I was struck by the fabulous embellishment of design and the use of metallic fiber on the vestments worn by priests. This was the impetus to really have fun with color, fiber, stitchery, and embellishment.

The piece shown in the color section was worked with metallic yarns, fine rayon ribbon, and fine cordé. The sign of the fish is repeated twice on the front. The back has a winged angelic effect. The buttons at the neck are old bronze ones that were part of my found-objects collection.

Often one particular crochet stitch will provide the amount of textural or surface interest that feels right to you. Note the use of the Judith Stitch (explained on page 61) on the back of the vestment.

"QUINTYCH"

Preoccupation with the classic religious works and the more primitive objects of art have caused a dichotomy in direction for me, as revealed in this piece (opposite). Maybe it is because in my heart

132

the most primitive and innocent is truly the purest form of religion in man. The gathering of mother and children—the most basic of our instincts—is represented here.

Each figure was worked separately, wood panels constructed and covered with muslin and single crochet stitched panels. The figures were then stuffed and sewn onto the crochet backing.

The materials were a combination of found objects used with hand-spun sheep yarn, weaving wool, loopy mohair for the hair done in a loop stitch, rayon ribbon, dyed cotton cord, mohair tops and glass and wooden beads. The very juxtaposition of diverse materials is perhaps part of the statement of this piece.

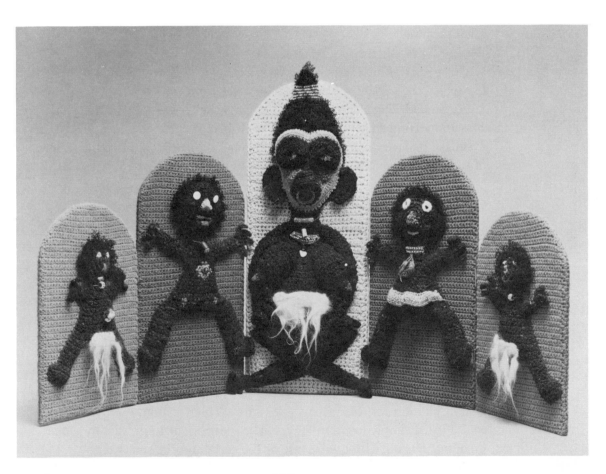

With crochet you can even begin with one form, as some two-dimensional shape, and be led to complete a three-dimensional object. During a workshop experiment with a group of students, we decided to use needlepoint mesh as a base or kickoff point. Given freedom of expression in the use of materials, I decided to limit my use of color in the piece so that the project was also a study in white. The result, using various yarns and featuring the loop stitch on top, gradually grew and took the shape of "Surrogate Baby" with arms always outstretched waiting for Mama.

Loop Stitch

Loop Stitch: Work a row of single crochet (right side of work). Chain 1, turn.

Row 2: * Pass thread around index finger of right hand, work one single crochet in next notch, take loop off finger *. These loops are formed on the back of the work (facing away from you).

Note: Should longer loops be desired, pass the thread around the first and second fingers. To obtain loops of a definite length and evenness, replace the middle or two fingers by a band of cardboard of the size required.

"SUNFLOWER"

The inspiration for this piece shown in the color section was two-fold. First, I simply love sunflowers. The great bright head, slightly drooping, fills me with a full sense of the earth and the sun. I espe-

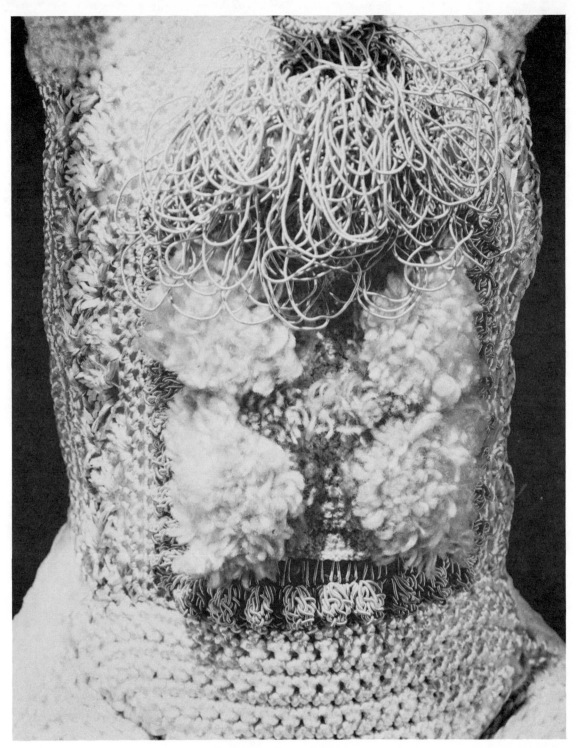

"Surrogate Baby," detail.

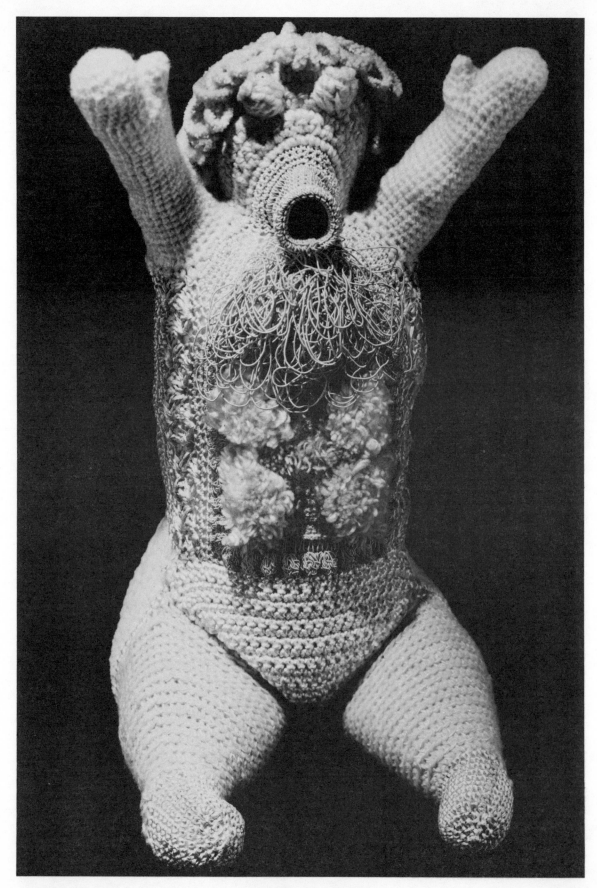

"Surrogate Baby"

cially love to dry the flower by turning it upside down and setting it on a table where we can eat the seeds right from the source.

Now, where would I start constructing such a piece? The Victorian pillow below set me off. Its raised stitch was done in a rayon-and-silk fiber . . . but I needed something more organic. I found a wonderful unwashed, hand-spun sheep yarn from South America that smelled of the earth. This had to be my center. Finding the color I wanted for the petals was a little tricky and led to much trial and error with texture. Finally I hit on some homespun Greek yarn.

(Photograph by Malcolm Varon.)

The first step was to crochet a circle in a natural color.

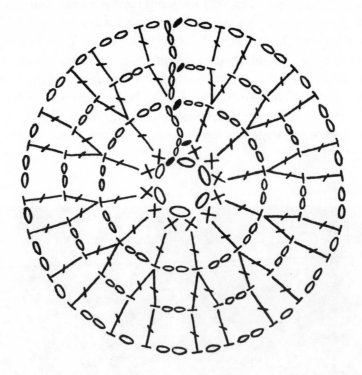

I picked up with brown hand-spun sheep yarn, working in double crochet in the raised stitch, and worked in a spiral, ruffling at the same time by doing many stitches in the same space.

Very often we use a stitch that has a lot of surface texture (such as a Popcorn Stitch) in order to give a two-dimensional quality to a piece. With the raised stitch, however, we can really be free of this kind of uniform surface. Using this stitch allows you to go in any direction like the sunflower or the Victorian pillow—*or* you can attach your yarn at any point in your work and, using whatever existing threads are available on the surface, simply work a single

crochet in any direction you want. This gives you a base stitch to work from and allows you to work up from your surface using any stitch you wish, increasing or not as desired to create ruffling or simple tubular forms and curved walls.

The diagrams show the various background shapes that you can start with when you are doing the raised stitch. The arrows point out the direction in which you crochet. The circle uses a

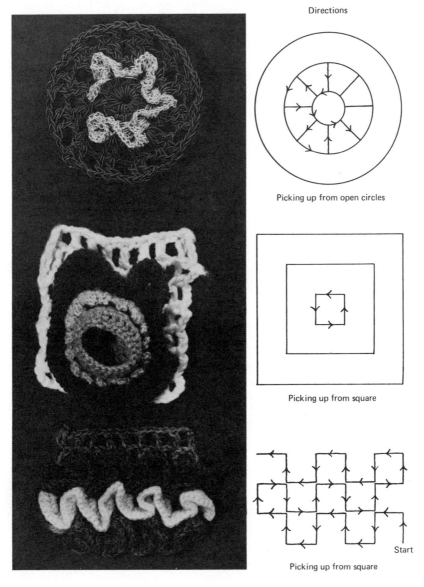

Directions

Picking up from open circles

Picking up from square

Start

Picking up from square

139

double crochet stitch with chains in between (enough to keep it flat) and will also give you enough space to put up stitches. The other drawings show how to work on a filet pattern square. Try crocheting a square using a double crochet—chain 1, skip 1 stitch from row below and double crochet. Continue for as many stitches as you like and as high up as needed to form a square. Then try the raised stitch, starting from the center and weaving in and around the bars formed by the double crochet. Chain 1 as in the diagram.

In the sunflower, each petal was worked as illustrated, but varying widths and lengths were used for a natural effect. The only other difference was that the outside petals have a row of single crochet, done in a straight line down the length of the petal, decreased at intervals to cause the petals to slant back slightly. The inside petals were done in a slightly deeper shade of yellow-orange with thinner yarn, and the increase on the outside of the petal

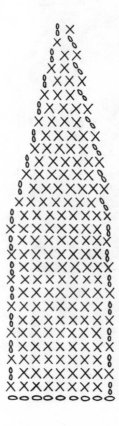

Finished petals for "Sunflower."
Facing page:

was slight—just enough to cause the petal to turn in and fall forward.

After all the petals and the center were completed, I constructed a sort of pillow in muslin stuffed with kapok. I then sewed the center of the flower around it. With soft armature wire, I carefully wove the wire into the row of single crochet behind the large petals that slant backward. Pinning the small petals that slant forward in first and then the large ones, I sewed the petals down with very strong thread to the back of the muslin cushion. Then another layer of muslin is sewn over the petals and a crocheted green cover goes over the last layer of muslin.

PILLOWS

The full-blown climbing rose pillow was done using the raised stitch technique on a round form base. The rose bud was started with a pointed tubular form which was then stuffed. Each petal was worked separately, decreasing along the edge of each one to make it curl, and then it was attached to the base with an embroidery needle and yarn of the same color. The stem was worked separately as a simple tubular form, and the leaves were picked up from the stem, using the raised stitch technique again. The stem was then sewn on the base of the bud.

The lilac has many tiny cylindrical forms picked up from a pointed tubular base.

"LANDSCAPE #2"

Living in the city can open one's eyes and sensitivity to nature. I keep looking at brick buildings and pavement and thinking of color and forests. Sometimes when I am crocheting a flower I feel nestled among them. I have tried to satisfy my desire for growth with lots of plants in my apartment, but it isn't the same sense of color one gets from riding through the hills and mountains in the spring, seeing buds bursting and color rising from the earth. As a result of these feelings a whole series of flowers and landscapes appeared

142

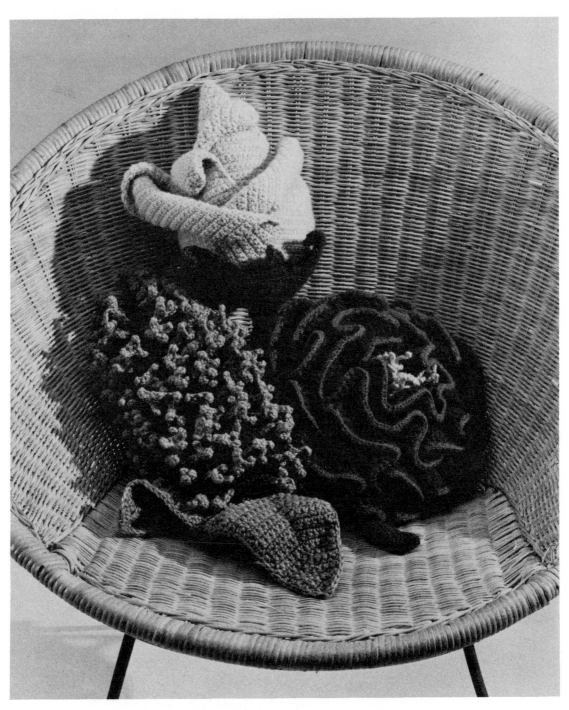

Several flower pillows.

143

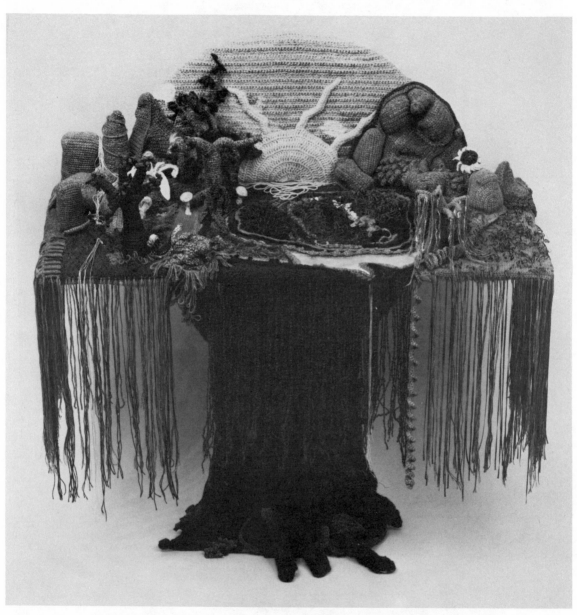

"Landscape ⧣2" which appeared in "Baroque '74" show of the Museum of Contemporary Crafts. (*Photograph by Bob Hanson.*)

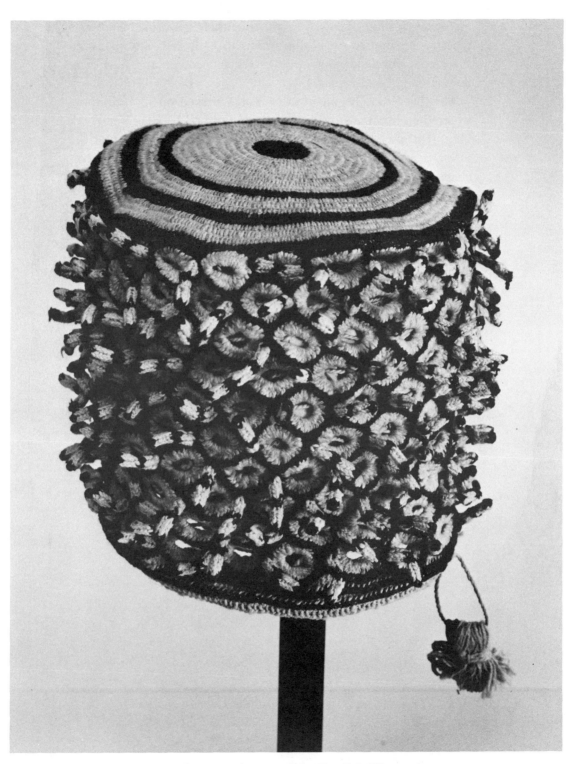

African headpiece. (*Photograph by Frank J. Thomas.*)

in my work. Starting with a two-dimensional abstract landscape tapestry, an impression of the woods in early fall, I went on to flowered plant holders, to pillows for my couch, to "The Sunflower" and "Landscape ⚖2."

This piece was begun in New York, worked on in California, where the mountains inspired me, and finished back in New York City. It is also shown in full in the color section. The base of the forest is wood covered with chicken wire and felt and then crocheted like the trunk of a tree. The tree looks as though it was cut down to reveal this miniature scene in an enchanted forest. Starting with the small green field, I proceeded without any real plan. "Landscape ⚖2" is the freest, most experimental work I have done—to this point.

Although not specifically inspired by seeing stitches in other pieces, I was immediately struck by the similarity of the forms used in this headpiece, subsequently seen in the Museum of Modern Art's African show, with the flowers in "Landscape ⚖2."

What makes any work unique is the intellect and emotion the craftsman puts into the ultimate product. The beauty he sees, the pain he feels, the peace he acquires, the glory that ensues—these we can see as soon as we look at the work. Without your emotional response, in my opinion, the piece isn't complete. My strand of yarn, delicately worked with love, pain, excitement and endurance, reaches out to you.